Hieronymus Bosch
Garden of Earthly Delights

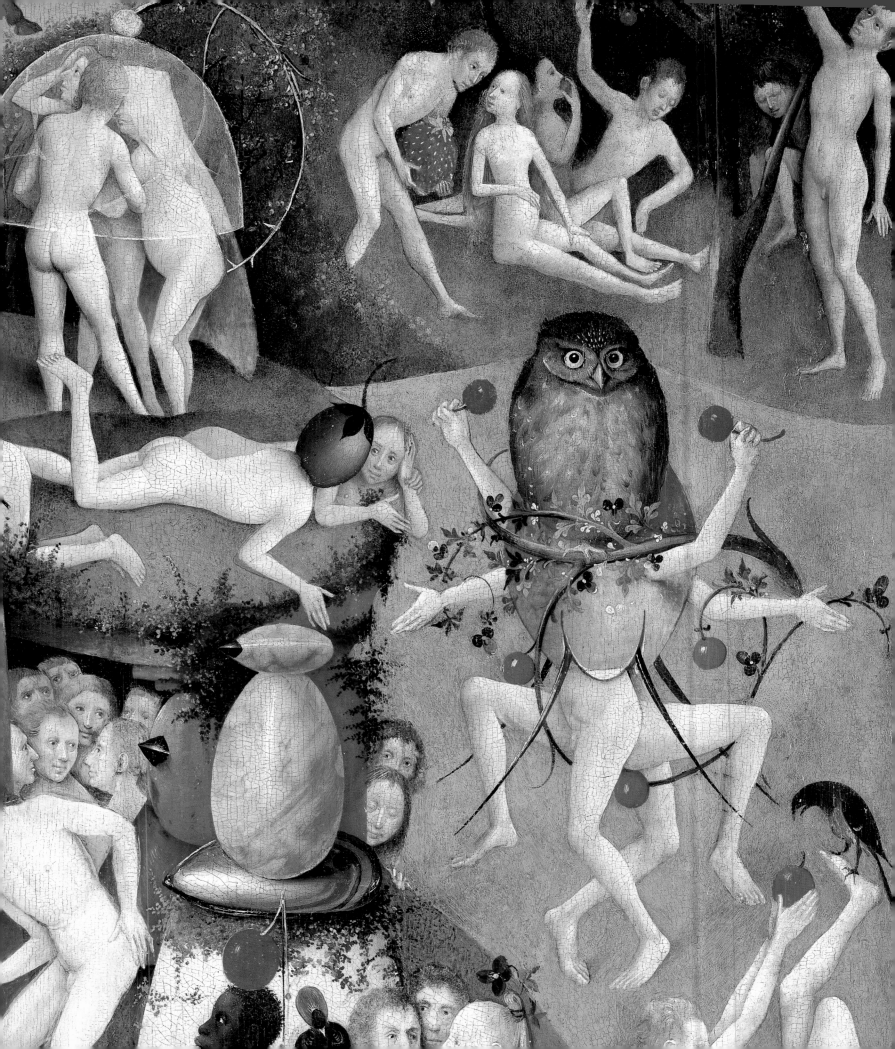

Hans Belting

Hieronymus Bosch

Garden of Earthly Delights

Prestel

Munich · Berlin · London · New York

In Memory
of
Dietmar Kamper

Pictorial material has been kindly provided
by the museums and lenders or has been
taken from the Publisher's or author's archives,
with the exception of the following:

Bayerische Staatsbibliothek, Munich p. 97
Bibliothèque Royale de Belgique p. 99
Bridgeman Art Library, London p. 72
Bob Goedewaagen, Rotterdam, p. 81
Kimbell Art Museum, Fort Worth/TX p. 6
Musée du Louvre, Paris, RMN p. 95
Musée du Louvre, Paris, RMN-R.G. Ojeda p. 67 top left
Museum Boijman Van Beuningen, Rotterdam, photo: Tom
Haartsen p. 63 right, 65
National Gallery of Art, Washington DC, © Board of Trustees/
Lyle Peterzell p. 67 right
Öffentliche Kunstsammlung und Kupferstichkabinett, Basel
pp. 107, 114
Palazzo Ducale, Venice p. 91 (illus. 1 and 2)
Royal Collection Enterprises p. 118
Scala Group, Antella/Florence p. 91 (illus. 3 and 4) and 92
Staatliche Museen zu Berlin-Preußischer Kulturbesitz,
Kupferstichkabinett, Berlin, photo: Jörg P. Anders p. 69
Städelsches Kunstinstitut, Frankfurt a.M., photo: Ursula
Edelmann p. 63 left
M. Willems, Ver. Heymans Bedrijven p. 94
Yale University Art Gallery, New Haven CT,
Photo: Geraldine T. Mancini p. 67 bottom left

Front cover: Hieronymus Bosch, *Garden of Earthly Delights*,
central panel (detail)

Die Deutsche Bibliothek CIP-Einheitsaufnahme data
and the Library of Congress Cataloguing-in-Publication
data is available

© Prestel Verlag, Munich · Berlin · London · New York, 2002

Prestel Verlag,
Mandlstrasse 26, 80802 Munich
Tel. (089) 38 17 09 0
Fax (089) 38 17 09 35

4 Bloomsbury Place, London WC1A 2QA
Tel. +44 (020) 7323-5004
Fax +44 (020) 7636-8004

175 Fifth Avenue, Suite 402,
New York, NY 10010
Tel. +1 (212) 995-2720
Fax +1 (212) 995-2733

www.prestel.com

Translated from the German by Ishbel Flett, Frankfurt am Main
Copy-edited by Christopher Wynne

Design and layout: Meike Weber
Origination: Eurocrom 4 s.r.l., Villorba
Printing: Sellier, Freising
Binding: Conzella, Pfarrkirchen

Printed in Germany on acid-free paper

ISBN 3-7913-2674-0

CONTENTS

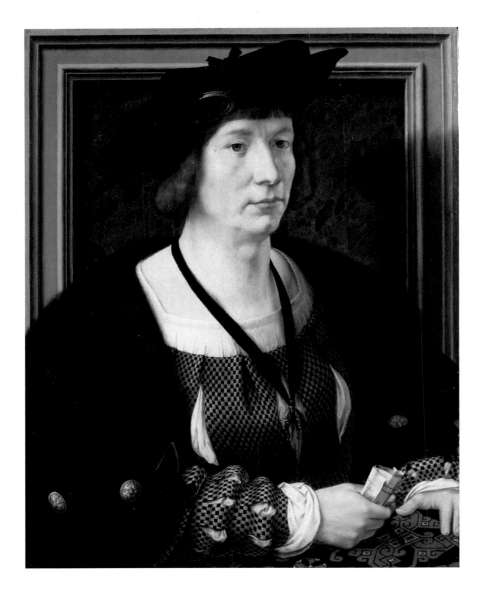

Jan Gossaert, *Portrait of Hendrik III*
Count of Nassau-Breda, *c*. 1517
Kimbell Art Museum, Fort Worth

The guardian of Emperor Charles V came into possession
of *Garden of Earthly Delights* as a young man.

A TALE OF FASCINATION

Ever since research on Hieronymus Bosch began, his paintings have captivated the imagination, exerting a fascination that has spawned an insatiable demand for ever new interpretations, none of them quite satisfactory. Not even repeated failure has stemmed the flow of proposals and, over the years, scholars of literature, anthropologists, historians and even novelists have joined art historians in celebrating the descriptive power of the word to convey the content of these pictures. What all of them have in common, whether they admit it or not, is their quest for a key that they hope to use for the work of Bosch as a secret code, as though the content could neatly be separated from this painted poetry. From the point of view of the surrealist, André Breton, in his *L'Art magique*, he even claimed for Bosch a gnostic approach that systematically denied easy access. He saw in the work of Bosch "a strange marriage of fideism and revolt." In the modern gaze, the ubiquitous presence of this œuvre has been in inverse proportion to the obscurity of its creator in the mists of history. In the absence of information about his life, the search was on for even the tiniest clue in his paintings. Modern cameras provided the mechanical eyes that were to track down new details that might just betray something.

Of all the works by Bosch, none is more fascinating than the painting known as *Garden of Earthly Delights* – a work of which we do not even know the original title. It is unsettling not only because the subject matter is so enigmatic, but also because of the remarkably modern freedom with which its visual narrative avoids all traditional iconography. The central panel of *Garden of Earthly Delights* is the apex of this unfettered venture into the realms of the imagination. The American writer Peter S. Beagle, who has published an excellent book on the subject, describes the work in terms of an erotic derangement that turns us all into voyeurs, as a place filled with the intoxicating air of perfect liberty. In his description, Beagle touches upon the same utopian aspect of the painting that informs my own interpretation of it. This is a paradise that does not exist anywhere because it has never become reality. Today, it would be called a virtual world. The *scandalon* in this picture lies in its eroticism, which is neverthlesss couched in biblical terms. The artist is not asking us to discover the sinfulness of the scene. That would indicate hereticism. Wherever the painter depicts his own world with mockery and pessimism, it is easier to accept his stance than it is when he paints a paradise that depicts neither earthly sin nor Christian heaven and which thus appears to represent an imaginary world.

None of this provides a satisfactory explanation for the fascination that this work exerts in the distorted mirror of a highly contradictory and controversial

range of interpretations. Art historians repeatedly admit, somewhat reluctant-ly, that, in spite of the triptych form of the painting, it was almost certainly not an altarpiece. Yet this tells us only that that Bosch adopted the form of an altarpiece for something that was never used as such. There is a similar con-tradiction between the ecclesiastic iconography of the middle ages and an ap-proach to art that heralds the coming era of art collecting.

Bosch stood between the generations that met at the threshold of the sixteenth century, and he gained personal freedom by his stance which was both 'no longer' medieval and 'not yet' modern. Had he painted scenes from classical mythology that were soon to gain a firm foothold in his homeland, *illus. page 72* we might have taken scant notice of his art. Instead, Bosch scholarship is fuelled time and again by a sense of some breach of taboo. We cannot help but be fascinated by his psychological and sociological realism. Yet the realist side of Bosch is of little use to us in interpreting *Garden of Earthly Delights*. For all his critical thinking, it is a work in which Bosch seems to clash against his own *weltbild*. How can this painting be interpreted so that it fits into the re-maining œuvre of the painter in the way the wing panels depicting Heaven and Hell do? No known commentaries dating from the period have survived, albeit with the important exception of one statement made almost a century later when the painting was already in Spanish hands, having been purchased from the confiscated estate of a Dutch rebel. In the Escorial, the monastic residence of that implacable enemy of heresy, Philip II, its imagery appeared alien and suspicious to the eyes of a new era, in spite of its fame.

The artist had to be cleared of the suspicion of heresy before he could even be discussed. As regards paintings in which questions of faith played a role, the royal collection was constantly under the keenest scrutiny. It was not just that the suspicion of heresy lurked everywhere; ever since images had become an issue in religious dispute, proof of the profoundest faith was needed to defend them against the iconoclasts. The fact that Bosch himself had not actually lived to see the Reformation was of little help. Bosch had to be proved "un-justly suspected of heresy," as the monk José de Siguenza warned the doubters who were already starting to dig for dirt. He added that viewers should not be blinded by the 'farces' (*disparates*) because Bosch had clad his truths with poetic licence. Indeed, he was to be credited with shedding light on the chaos and sins of man's soul (as opposed to man's outward appearance) in a manner so unprecedented in the tradition of painting that there were no rules for him to break.

In the *Garden of Earthly Delights*, the librarian of the Escorial draws upon a formula that had already played a role when the painting was recorded in the inventory of 1593. For him, the strawberry is a symbol of the *variedad del mun-do*, alluding to the foolishness, inconstancy and fickleness of the wicked world.

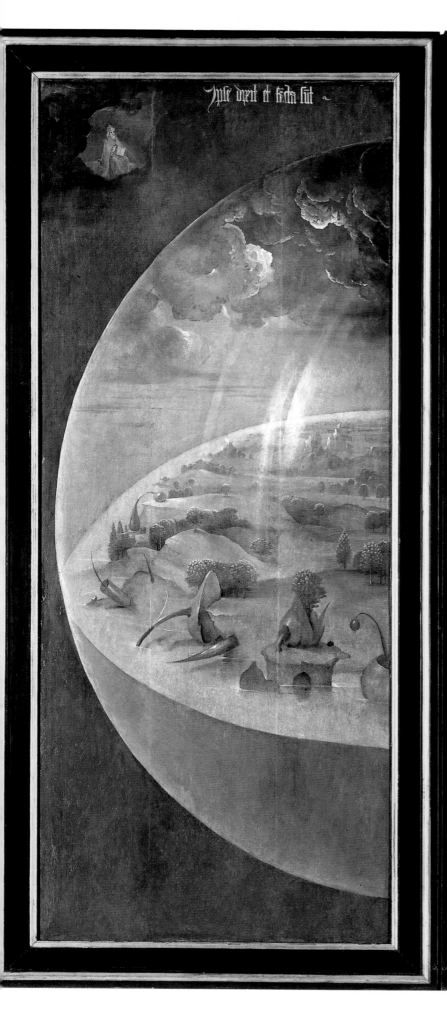
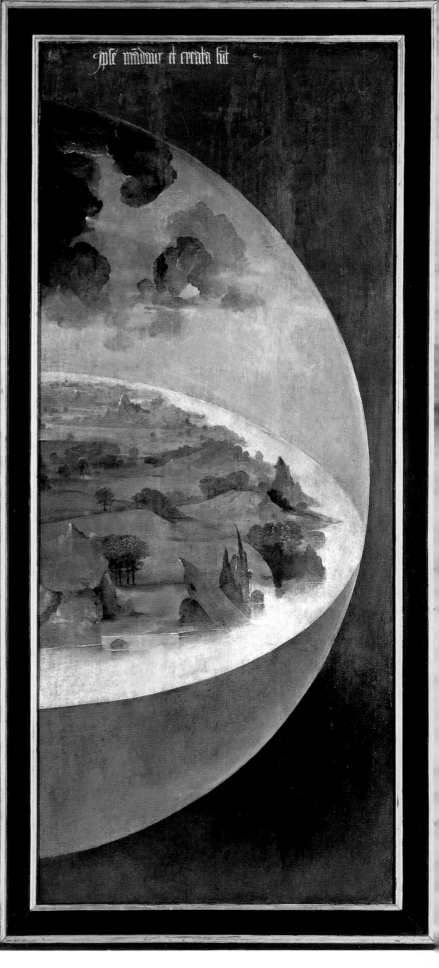

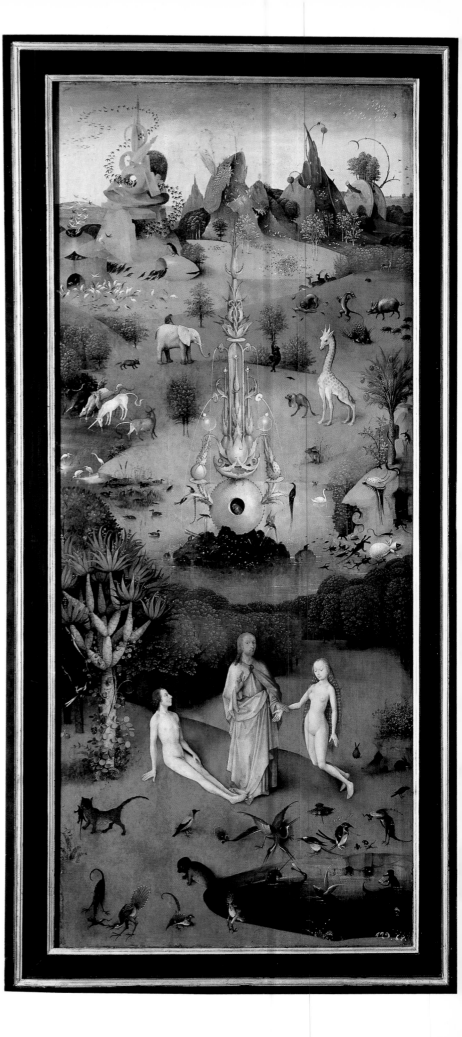

Hieronymus Bosch
Garden of Earthly Delights, 1480–90
Triptych, oil on panel, 220 x 195/390 cm
Museo Nacional del Prado, Madrid

Overall view with wings open*:*
Paradise (left-hand panel), *Imaginary Paradise*
(central panel), *Hell* (right-hand panel)

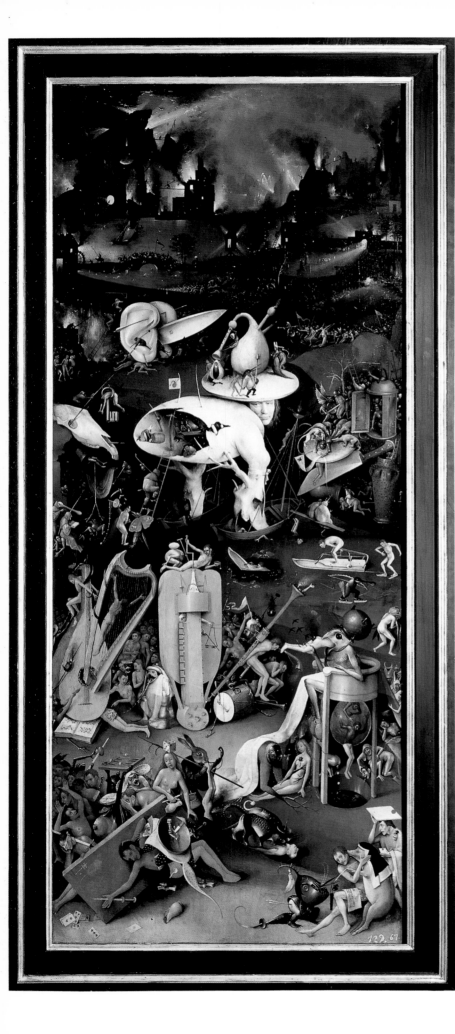

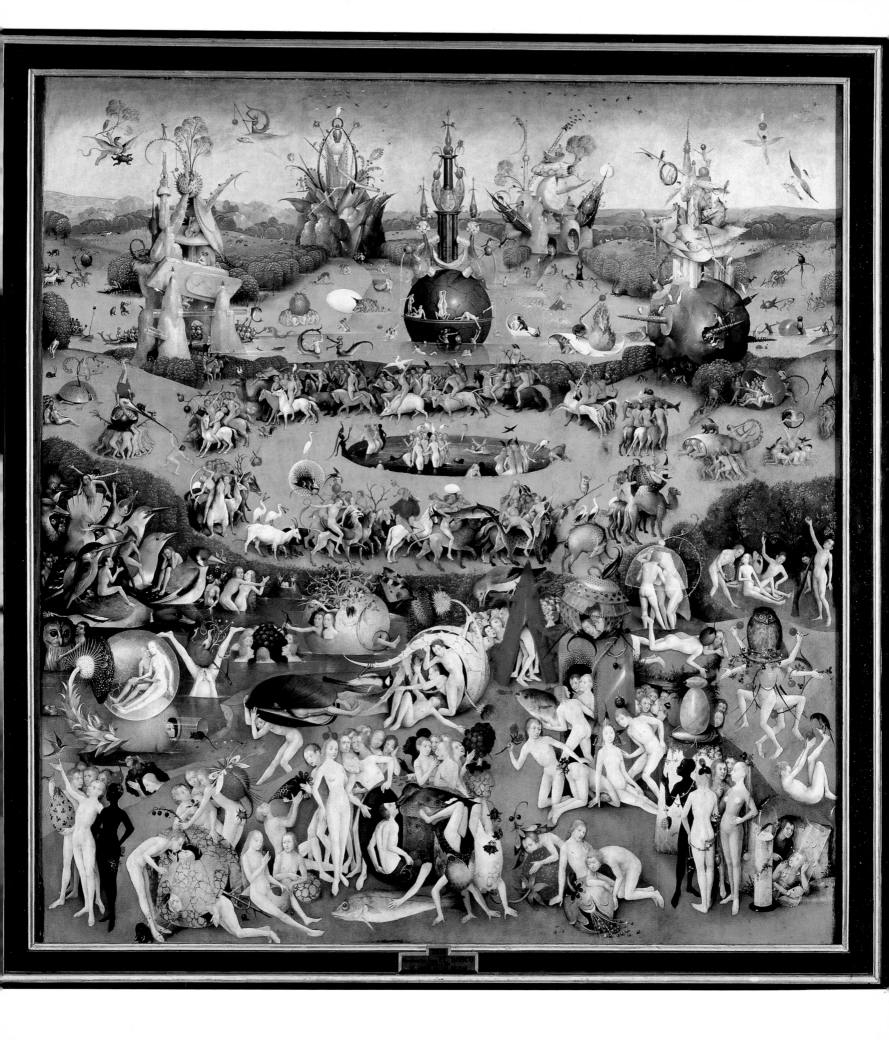

By this time, enigmatic pictures had become fashionable, pandering to an emblematic and coded notion of art. Accordingly, Sigüenza singles out the strawberry and takes its moralising messages as a key and motto for the entire painting. The 'fleeting taste of the strawberry' was indicative of the transience of sensual pleasures in the sexuality portrayed. A great mind, he continued, could conceive a useful book on the subject of this painting – the vanity and emptiness of the world – with all the freedom and originality of Bosch himself.

Sigüenza also focuses on the wild animals that men are riding around the women's pool, and interprets them as allegories of sinful passion. Ancient philosophers, he points out, also used animal roles to signify human vices. Thus, for Sigüenza, the view of paradise is transformed into an emblem of earthly vice, as though nothing in Bosch's painting could be taken at face value, and as though the temptations of beauty were merely a deterrent. What dominates here is an aspect that also plays an important part in other paintings by Bosch, seen through the eyes of a new era reluctant to take too close a view. Bosch did not paint his picture for the distrusting eyes of a clergy that is hardly flatteringly portrayed in the Hell panel. Whereas Sigüenza saw the painting merely as a mirror of a sinful world, Bosch forced the spectator to gaze upon a painted paradise as though upon an innocent counterworld in which his own standards of guilt and sin did not apply. We shall return to this point later.

illus. page 19

Only on the Hell panel did Sigüenza effortlessly pinpoint the content of the picture, albeit without actually realising how starkly it contrasted with the portrayal of Paradise. The hellish domain, he writes, brutally reveals "the miserable goal of our labours. Anyone relying on music, obscene song, gambling and dancing for his entire happiness" had foolishly relied upon "a brief moment of pleasure" that would be followed in the afterworld by "eternal wrath with neither mercy nor succour." Bosch had no need to prove the purity of his faith in his portrayal of Hell, and could let his imagination run free, but he created a profoundly ambiguous image. It is not possible to discover a coherent linear narrative between the three panels in the manner of other works such as the *Haywain* triptych (p. 86). The connection, if indeed there is any, between the central scene of Paradise and the adjacent Hell panel, is not at all what Sigüenza perceived.

In Sigüenza's day, Bosch already stood accused of heresy. In his book on human dreams, the Spanish writer Francisco Gómez de Quevedo (1580–1645) portrays the artist as a visitor to Hell, where the devils themselves complain to Bosch that he has made them mere figments of his dreams; the painter replies in his defence that he does not believe in the devil's existence. That in itself would have been a dangerous admission to make before the Inquisition,

pages 15, 16, 18:
Central panel (details)

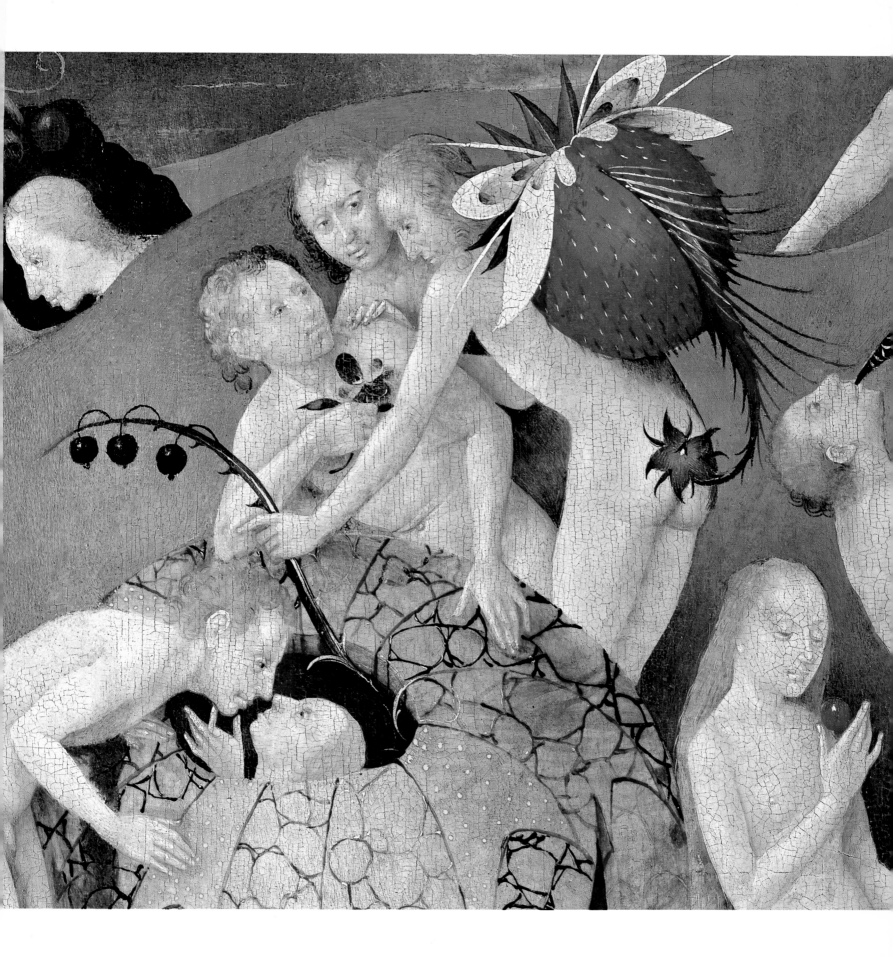

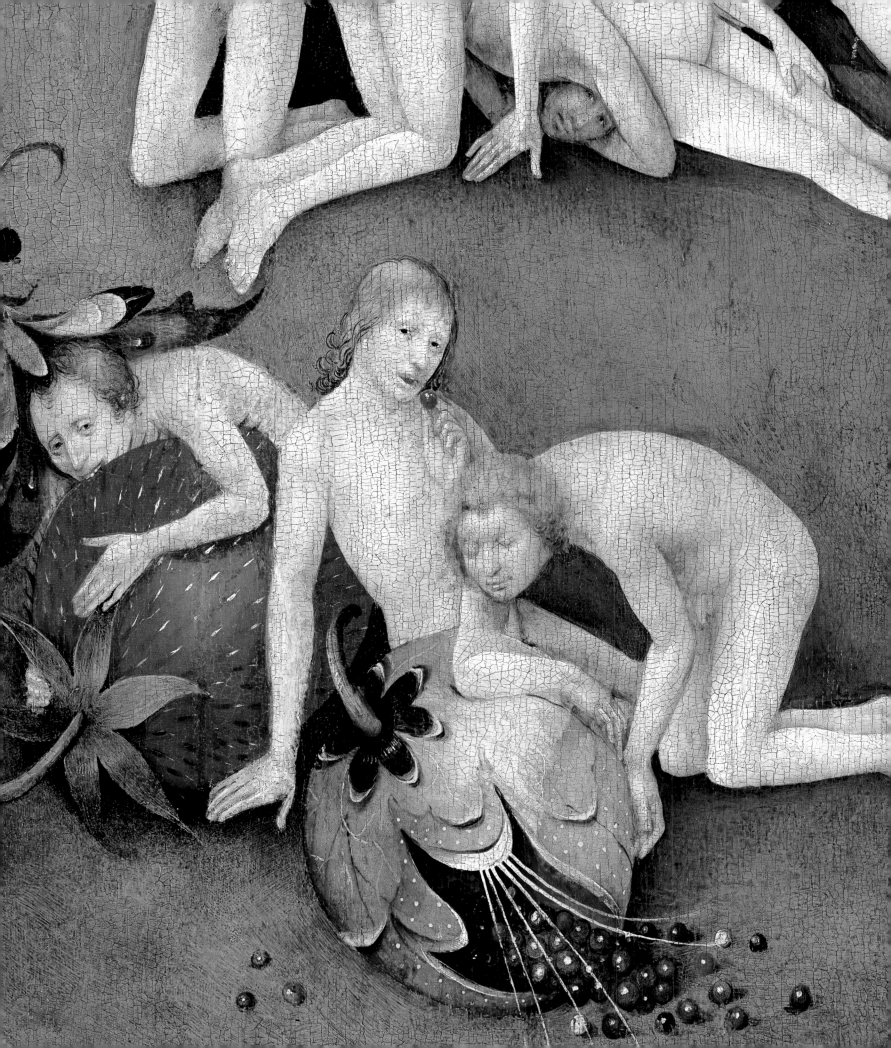

to whose scrutiny he was constantly subject with his highly visible works. Yet Quevedo's depiction is interesting because it inadvertently alludes to Bosch's approach to art, which is frequently overlooked in interpretations. When Quevedo accuses Bosch of painting a personal dream world instead of ecclesiastical truths, he is referring to an artistic imagination unfettered by the specifics of content.

This brings us to the problem that has tormented modern analysts of *Garden of Earthly Delights*. They have sought a hidden but unequivocal meaning that could be deciphered in such a way as to describe a content independent of Bosch's art. The artist's chosen form of expression was ignored, as was his approach to art, in which content was the means rather than the end. Modern viewers clearly found it difficult to imagine that Bosch, with his religious themes, wanted to create an art that would emancipate him from subjugation to the clergy and their sermons. The authors of the secular literature of his time with whom he vied had already found their literary freedom. Bosch, on the other hand, had to convince the spectator that the religious themes in his work were reflections of a profoundly personal art. Given that the contents of religious statements were otherwise strongly reglemented, art permitted an imaginative freedom that Bosch was able to vindicate only through the success of his own work.

In other words, it was not just a question of personal success, but of successfully establishing a form of art that had not existed before – at least not in the realm of painting, where the tradition of craftmanship long remained a stumbling block to the kind of freedom already enjoyed in poetry and literature.

This has resulted in a paradox: many modern scholars are fascinated by Bosch's art, yet seem to deny or forget that fascination the moment they start discourses on his subject matter. They begin to discuss religion and society in the age of Bosch, while barely mentioning the language of his historical imagery. Though this work has occasionally been the subject of motivated analysis, for the most part it has survived an ever changing parade of fashionable interpretations. An excellent example of this is the strange case of the German art historian Wilhelm Fraenger, whose description of Bosch as a free spirit operating behind the back of a militant church was very much rooted in the fears and hopes of the 1920s and earned him much admiration among lovers of Bosch. His interpretation of the painting in question as an "ideal realm of love" in a millenial utopia, had to be based on the assumption, as Fraenger himself admitted, that it had been commissioned by someone in a heretic group – an assumption for which there is no basis, given that the identity of the owner is now known (p. 71).

Another long-standing debate was conducted on the subject of alchemy, which would have been far less interesting without the visual evidence as provided by Bosch. In this case, however, the discussion was not aimed at furthering an understanding of Bosch the painter, but at gathering evidence for the mystical or hermetic variations of ancient alchemy as portrayed by Marguerite Yourcenar in her novel *The Black Flame*. The alchemistic motifs undeniably present in Bosch's work were taken as codes for an underlying secret rather than as critical or satirical observations by the painter. The modern age thus came to regard Bosch in a very different light to that of, say, Leonardo da Vinci. Although he belonged to the same generation, he did not represent the artist myth of the Renaissance. Nor was there a tradition of old Dutch art literature that could have been taken as a source. Bosch thus came to be regarded as a maverick whose paintings expressed the mysteries of an era in transition, rather than exploring a prevailing notion of art.

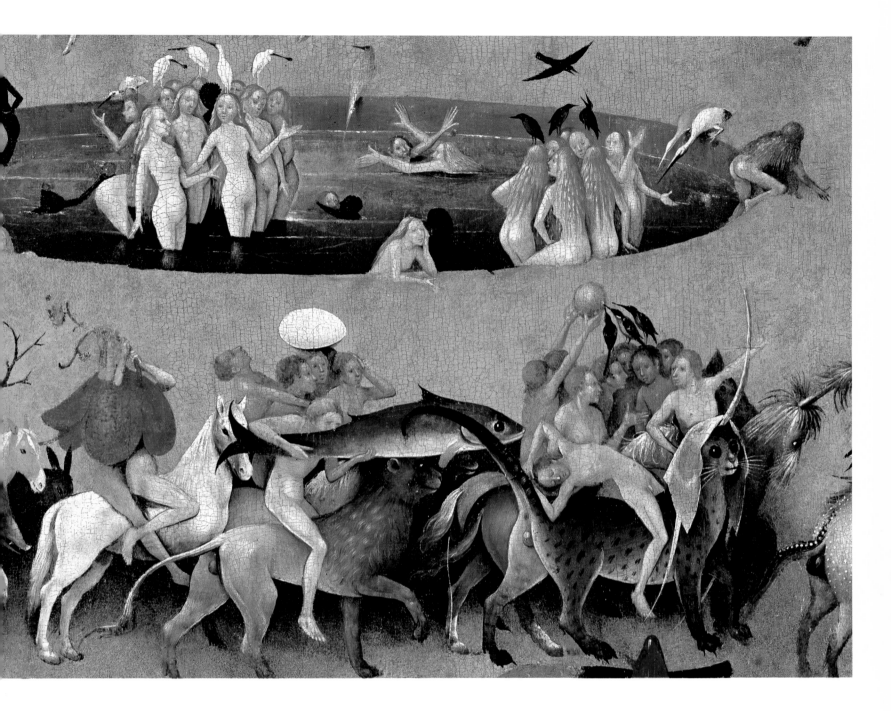

IN A PAINTED LABYRINTH
OF THE GAZE

In the *Garden of Earthly Delights*, Bosch lures us into a kind of labyrinth in which we are easily confused by the variety of motifs because we are not given any point of reference that might guide us safely to our theme. We are in constant fear of missing a motif that harbours some clue as to the overall meaning. Any description aimed at addressing each individual motif would be an interminable undertaking doomed to failure by the sheer scope of the enterprise. Thus, Bosch's artistic strategy actually places limitations on conventional descriptive approaches. Starting with the remarkably laconic exterior, which acts as a prologue to the exuberant narrative on the interior. *illus. page 23* When the triptych is opened, we are led, in the sequence of reading, at the left side into a Paradise consisting of a single scene that features the Creator *illus. page 24* with the man and woman he has made. The horizon and landscape continue *illus. page 46* into the next wing, but here the narrative tumbles helter-skelter across a teeming stage. The mood changes suddenly once more in the night-time scene of Hell, which appears in the foreground like a torture chamber and *illus. page 34* darkens towards a background filled with countless episodes. Do these heterogeneous views of the work fit together to make a single cohesive statement or does Bosch force us to conjure up free associations between the three panels?

Even the narrative style itself defies conventional modes of description. Whereas the spectator's gaze is normally guided by compositional structure, here we become lost in an overfilled panorama whose motifs appear like a compendium but cannot be read like one. We are given a view of them that was old-fashioned even then. It is a view that precludes a fixed viewing point which had become already the norm in painterly perspective. Instead, it creates a view from above, redolent of early illuminated manuscripts, that offers a survey of a broader narrative space. Indeed, as in a medieval simultaneous stage, spatial perception actually functions as a means of narrative rather than from a new spatio-temporal viewpoint. It is not the perspectival space, but the sum of the many motifs that Bosch uses as signs of the world. He registers the world as it is without subjecting what goes on in the world to any linear narrative. We should not be misled by the seemingly archaic style, which has prompted many theories about Bosch's early career as an artist. His imagery is the product of a crisis in the visual representation of the world. Gone is the innocence of sensual perception in which the older generation of Flemish artists once delighted. Bosch repeatedly reveals the illusory aspect of the way things look in reality, but has to take recourse to allegorical

codes in order to do so. In this respect, his work has affinities to the writers of his day, who opened their readers' eyes to the abyss beyond the surface of things.

illus. page 23

If we bear all this in mind, the individual panels of our triptych can be described in a logical sequence which also reflects a possible time frame of events. If we consider the work when closed, the creation of the world preceeds the history of humankind, which is shown inside. Following the direction of reading from left to right, we initially see the creation of the first man and woman, in Paradise, which, of course, took place long before the creation of a populated Hell. Only the central panel, on which Bosch has placed the main focus, does not fit into this time sequence. It was precisely this unexpected break in the narrative that Bosch intended in order to build up the argument that is the message of this work.

The World before Humankind

There is remarkable consensus regarding the exterior of the triptych (220 x 197 cm). The world as earthly paradise is depicted on the outer panels, populated only by plants, on the Third Day of Creation according to the Book of Genesis. Also missing are the colours that could not have been discerned before the creation of the sun and the moon "to give light upon the earth." According to the Bible, "God said, Let the waters under the heaven be gathered together and let the dry land appear." The biblical description fits perfectly wit the Ptolemaic notion of the earth as a flat disc surrounded by waters. The "herbs yielding seed ... and the tree yielding fruit" are shown submerged in the dusk that lay upon the world before the creation of "lights in the firmament of the heaven." If we still knew the map of the world painted by Jan van Eyck, the unpeopled version proffered by Bosch would be its very antithesis. Even at the time, any viewer of this triptych would have noted that Bosch's choice of non-colours for the exterior panels was in fact quite conventional. Yet he uses this convention in a very different way. Instead of portraying the patrons of the triptych and a trompe l'œil representing the mortal world, Bosch recalls the world before humankind. It was an almost unprecedented subject, for instead of portraying the act of Creation, it showed the cosmos as a glass globe whose walls refract light. The globe, used by emperors as the symbol of their global power, is suspended here in a void and surrounded by an impermeable darkness that symbolises a world before and beyond Creation.

It is here, in this dark nothingness, that God is placed. Wearing a crown reminiscent of the papal tiara, he is a tiny figure seated far away in the top left hand corner, and his gesture seems hesitant, almost shy, as though the world

21

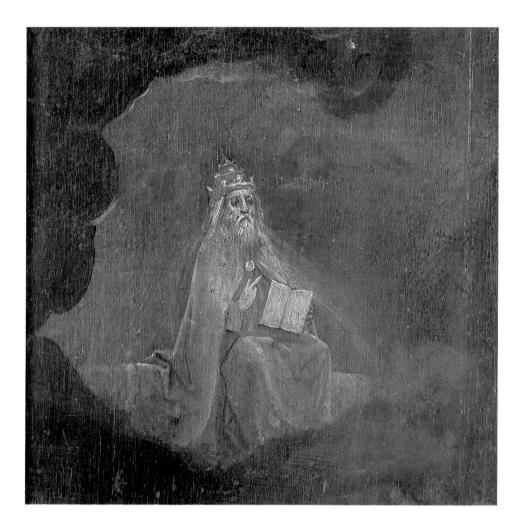

he had created was already slipping beyond his control. He has the Bible on his lap, as though in need of a script by which to create the world. Bosch has added two inscriptions in Latin. Yet instead of quoting the Book of Genesis, as one might expect, the words are taken from one of the Psalms of David: "For he spake and it was done; he commanded and it stood fast" (Psalm 33:9). The psalm that Bosch quotes is a free rendering of the story of Creation, just as Bosch himself took recourse to poetic licence in his portrayal. This is a subtle nuance that merits closer scrutiny, for it introduces the aspect of an author who has translated the first book of the Bible into a motif of his art. By presenting this quote, Bosch invites us to read the rest of the Psalm, which tells us that "The Lord looketh from heaven," describes how "He gathereth the waters of the sea together," and proclaims God's dominion over the underworld.

The outside of the triptych is a painted song of praise to Creation, focusing on the unfinished design for a world not yet misused by humankind. The artist responds to the theme by foregoing the use of colour. The picture, which resembles a cartographic model rather than a narrative, is split right down the

middle by the frames of the panels, arousing our curiosity as to what lies within. In this respect, the closed work symbolises a world unopened. The relationship between exterior and interior is similar to that between design and execution or between the idea of a project and its result. This first impression of a view of the world is thus transferred from the exterior to the work as a whole. Anyone who has ever stood before these huge exterior panels in all their gloomy emptiness soon realises that the very act of opening the wings to reveal the interior must surely have been an essential element in the dramatic effect of the work. The effect of the original *mis-en-scène* will be discussed at a later point (p.78).

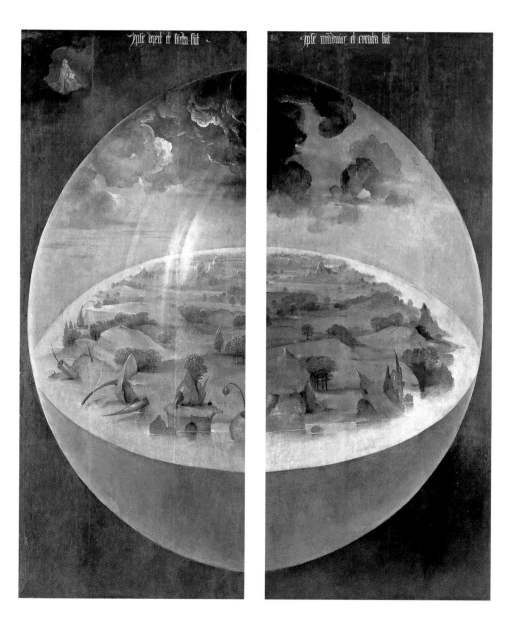

The closed triptych: *Creation*

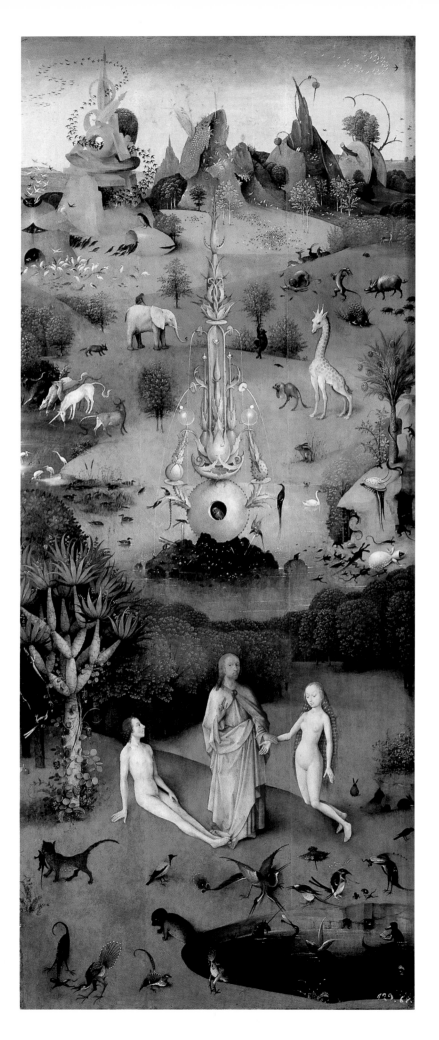

Paradise (left-hand panel)

illus. page 86

illus. page 30

illus. page 28

illus. page 29

The interior catapults the viewer's gaze into a scene of such stark contrast that there is an automatic tendency to look away and focus first on the left-hand panel. This is, as it were, the overture, played in a calm adagio. The endless expanse of the setting, a kind of universal landscape, iconographically features a biblical episode, but only in the foreground. The portrayal of the first man and woman, created and introduced to one another by God, clearly indicates that this is the Paradise described in the Bible. Yet unlike the Paradise panel of Bosch's *Haywain* or his *Last Judgment* now in Vienna, there is no indication of the Fall of Man, which opens the door to a history of the world beyond the Garden of Eden. Instead, Bosch has chosen to render an unusual scene in which God – whose likeness to Jesus foreshadows the moment when the Word becomes flesh as the 'new Adam' – presents the woman to the man in order for them to become a couple. The omission of the Original Sin is an anomaly that deserves closer consideration in respect of the central panel. Only the serpent coiling discreetly around the trunk of a palm tree in the middle is waiting for the opportunity to tempt Adam and Eve into partaking of the forbidden fruit of the Tree of Knowledge.

Bosch follows the text of the Bible as closely here as he does on the exterior panels. According to the second chapter of the Book of Genesis, God made woman from the rib of Adam (whose creation is described in the first chapter of Genesis) "and brought her unto the man" (adduxit). The painting shows the moment when Adam awakens from his deep sleep during which God had removed one of his ribs. He sits up and stares in wide-eyed wonder at the lovely Eve who chastely casts her gaze downwards while seductively presenting her body to Adam. The Creator, who is holding her by the wrist, is giving the sign of his blessing to their union, as though to say, as in the biblical text, "It is not good that the man should be alone" (Genesis 2:18). The Bible continues "… and they shall be one flesh. / And they were both naked, the man and his wife, and were not ashamed" (Genesis 2:24, 25). The significance of the "blessing upon marriage" as Augustine describes the scene in his City of God (Book XIV, chapter 21) is made clear in the central panel, where a group representing members of different races, one with arm outstretched, looks towards the first couple. Indeed, the scene with Adam and Eve is only there because of the adjacent scene, which is why it is to be interpreted later. It is possible that Bosch's portrayal of marriage was intended as a jibe at the Inquisition's animosity to all things sensual, as Rosemarie Schuder has suggested. However, as we shall see, this does not refer to the model of the Christian family. Behind Eve's back, the frolicing rabbits signal fecundity while the dragon-tree on the other side, according to Robert A. Koch, is an unusual symbol of eternal life.

Bosch concentrates more on the poetic portrayal of Paradise than on the biblical scene presented within it. What we see is a universal landscape – after all, the great plan of Creation envisages the entire world as Paradise – and, at the same time, the exotic lands of the far east as imagined in Bosch's day before they had been charted. At the centre is the fountain of Paradise that watered all the lands, portrayed here as a hybrid growth of flesh-coloured protuberances set in a shimmering blue lake. At its centre, like an eye, is a dark aperture in which an owl – Bosch's ambiguous creature of the night – destroys the innocence of the scene. The violence of some wild animals counsels us to regard the idyll with scepticism. After all, the Original Sin was already anticipated in Paradise by the very fact that it was forbidden to eat from the Tree of Knowledge. In the foreground, all manner of fantastic animals are at play in a little pond, among them a beaked creature in a monk's habit reading from a book.

illus. page 33

The hybrid fauna and flora provide the key to Bosch's artistic strategy. Wherever their forms defy all possible interpretation, they are fodder for Bosch's love of imaginative lyricism. In the Bible, Adam is allowed to name "every living creature." Just as God created the animals, so it was left to Adam to invent their names. Bosch takes pleasure in translating this encyclopaedic nomenclature into a visual encyclopaedia teeming with creatures that cannot be found in any bestiary. The painted garden is full of creatures with neither name nor real existence, representing the boundless possibilities of Creation. The blend of nature and fiction in Bosch's idiosyncratic mimesis of Creation extends the genres of fauna and flora beyond the bounds of a world which, in those days of exploration and the recent discovery of America, seemed to be expanding daily.

Even in his forays into the realms of the exotic, Bosch still appealed to the knowledge of a humanist and aristocratic readership. The giraffe and the elephant, to name but two examples, reiterate illustrations from travel descriptions in the scholarly literature of the fifteenth century. For a long time, art historians believed that these two animals were based on Erhard Reuwich's pictures for Breydenbach's *Pilgrimages to the Holy Land* (1486). However, Phyllis W. Lehmann has identified them as based on drawings made to accompany the travel letters by the humanist scholar Cyriac of Ancona. Cyriac visited Egypt several times in the 1440s and reported on ancient monuments and exotic animals unknown in Europe. Giacomo Rizzoni hailed him in a letter of 1442 as "a painter, rather than a hunter, of wondrous animal species." Martin Schongauer also used the exotic imagery of the travelogue in his art. In his famous engraving of the *Flight into Egypt* he provided his own views of dragon-tree and date-palm, repeated almost literally by Bosch: art quoting art.

illus. page 31

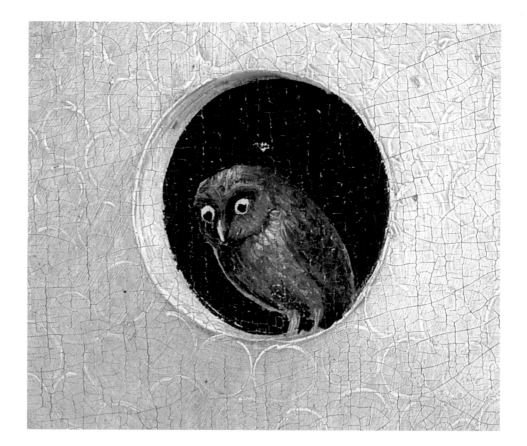

Paradise: the owl

The works of Cyriac of Ancona were for the most part sumptuous manuscripts accessible only to society's educated elite. References to his works in the *Garden of Earthly Delights* would therefore have been understood only by members of such circles. Yet the exoticism presented by Bosch in a combination of scientific precision and free imagination touches the very pulse of the era. The period around 1500 was one of discovery and conquest. Any available descriptions of distant lands were dated and so the only way to find out about a dramatically extended world was to travel oneself or glean information from objects brought back as souvenirs. At the time when Bosch's *Garden of Earthly Delights* was put on display in a Brussels palace, the first trophies were arriving from the New World to the delight of even such conservative minds as Dürer (p. 101). Bosch himself had no information about this part of the world to fall back on when he painted *Garden of Earthly Delights*. It was created a time when a new form of exoticism was beginning to emerge in place of the older one. Exoticism at the time meant a certain curiosity that was no longer satisfied by the traditional views of the world, but which sought to discover the planet. Bosch himself retained a sceptical attitude, blending semblance and reality with his own distinctive lyricism that paid little heed to the expanding geographic knowledge of the world.

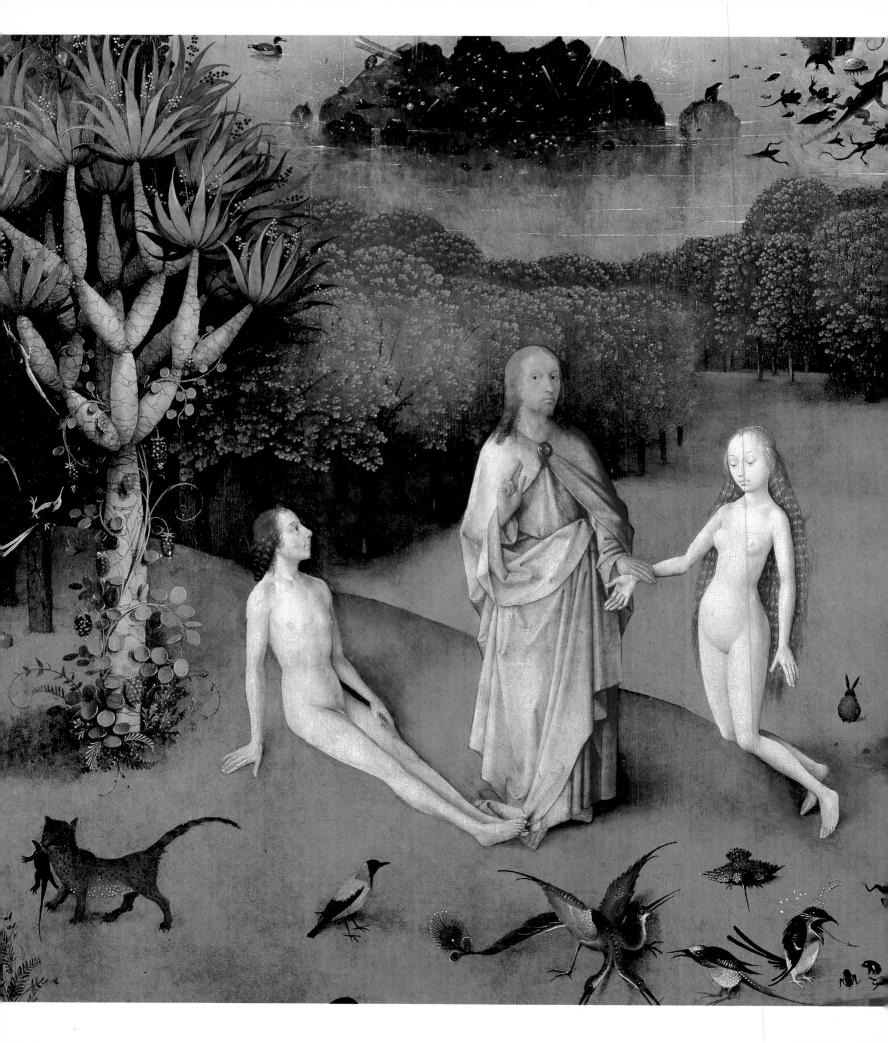

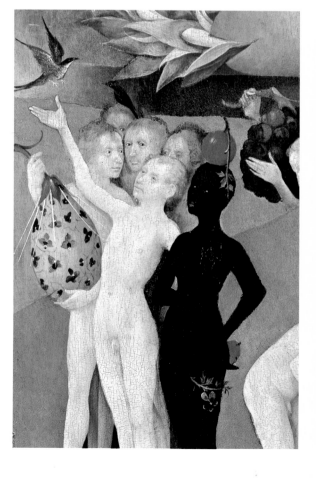

Paradise: the marriage of Adam and Eve

People of different skin colours
facing a common future

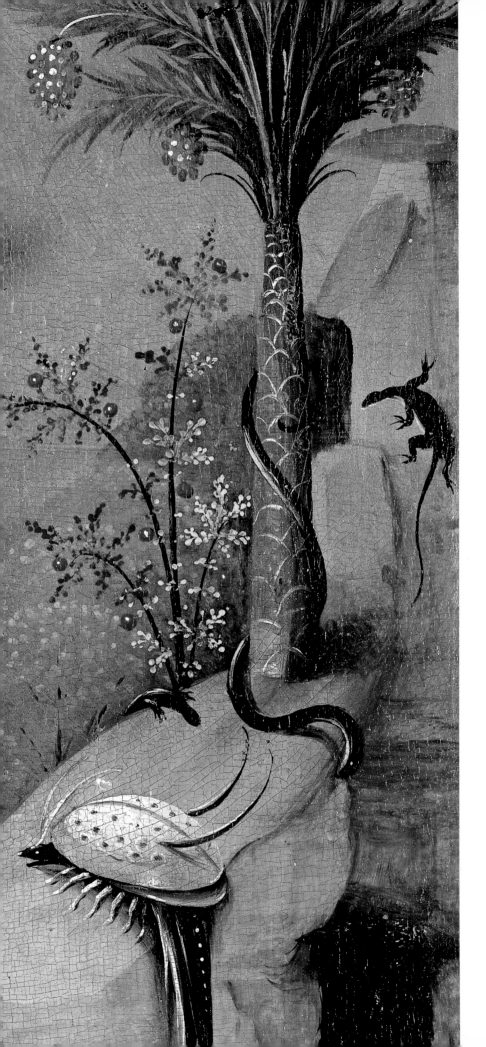

Paradise (details)

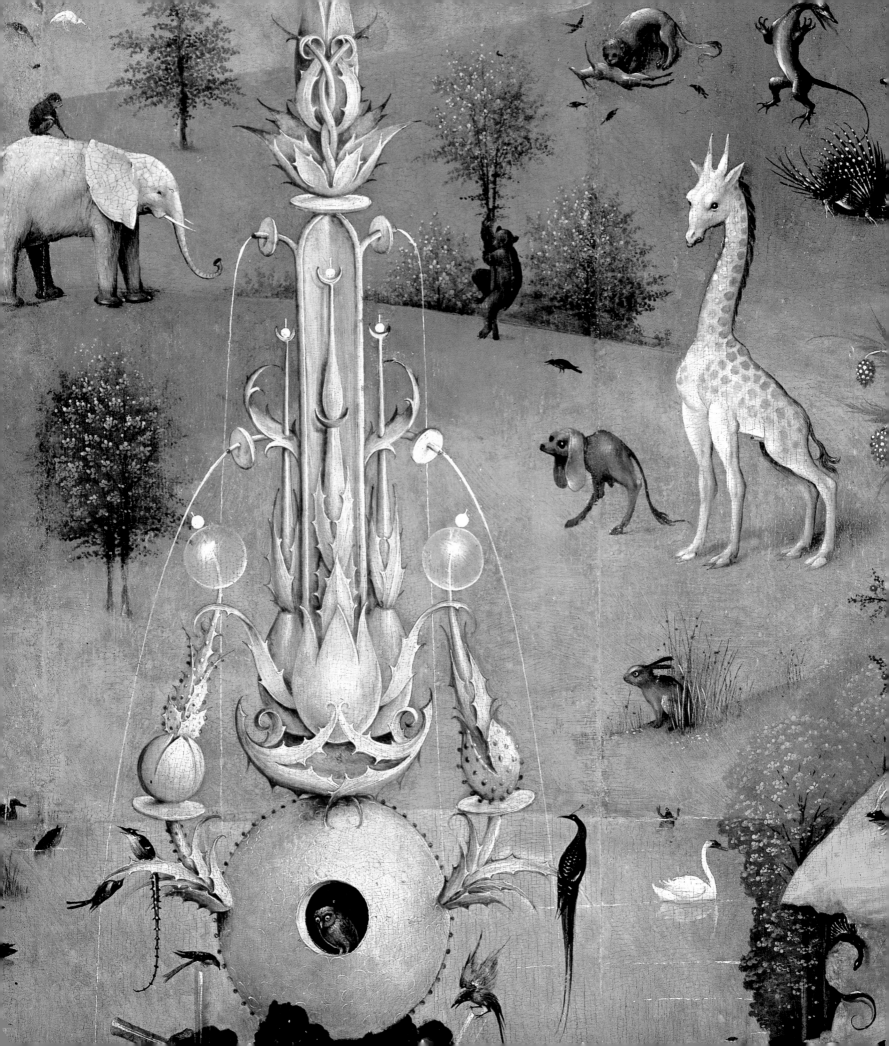

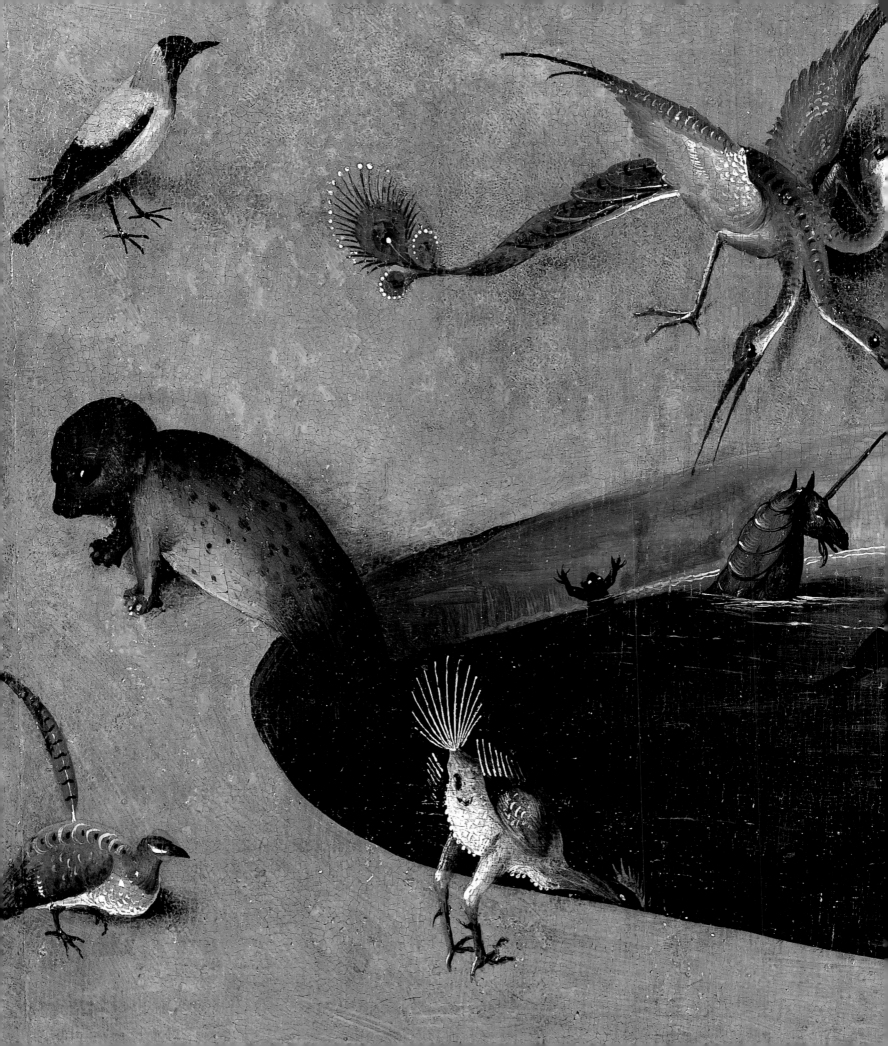

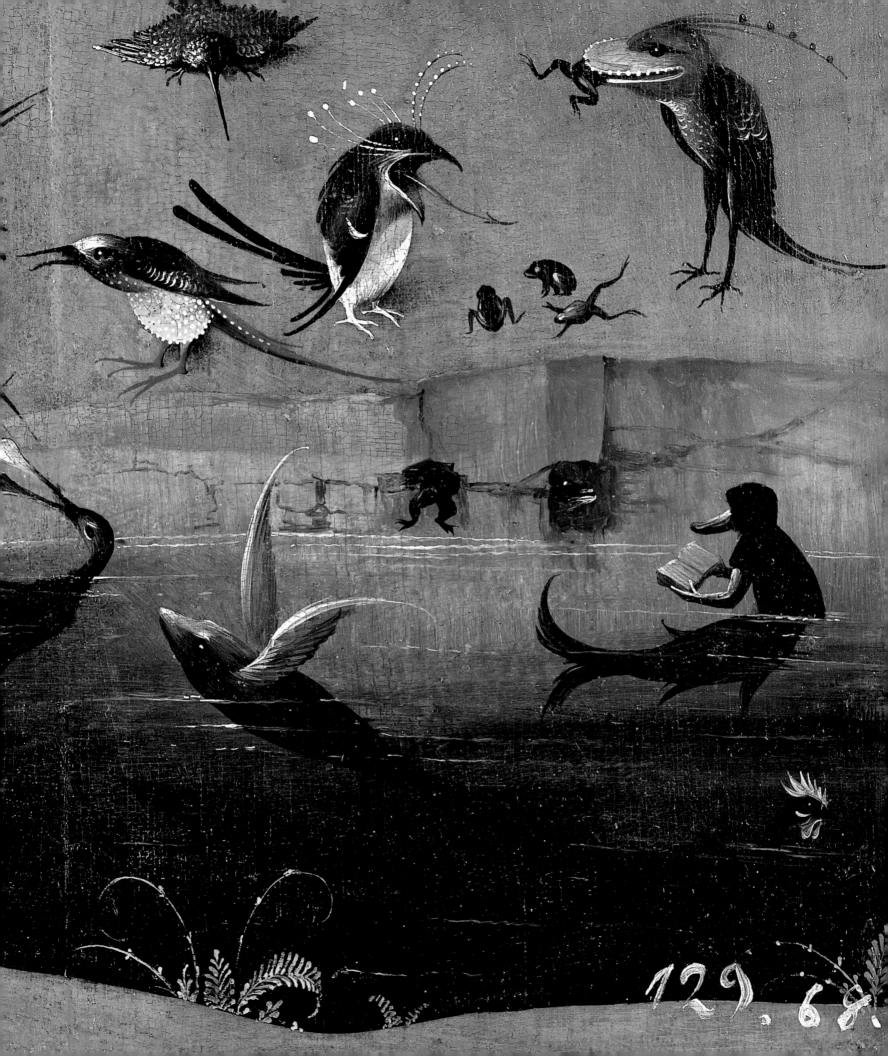

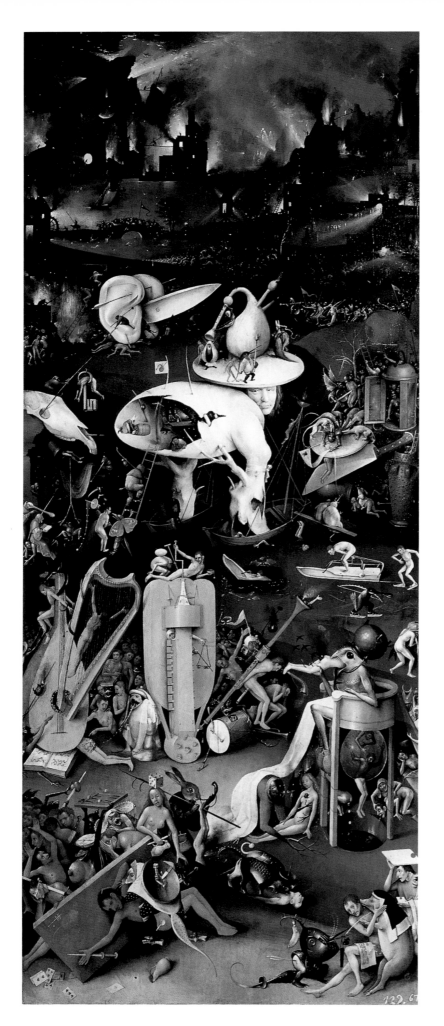

Hell (right-hand panel)

The Hell panel, which has been interpreted more fully than the others, prompts comparisons with similar formulæ in Bosch's œuvre. At the same time, in the context of this extraordinary triptych, it represents an extra-ordinary heightening of iconographical conventions. It stands apart from the other images in the work not only because it is a night scene, but also because it completely omits nature. Human beings exist here, not in natural surround-ings, but in a civilisation they have created themselves: cities ravaged by war, taverns full of drunkards, torture chambers where cruelty reigns supreme. Even the musical instruments are human inventions that turn against mankind in this place. Fantastic as the imagery may be, there is little here that humans have not brought upon themselves. They have succumbed to the temptations of the devil, who now reaps the reward of tormenting them in all eternity. Though the Hell that Bosch portrays certainly corresponds to the pre-vailing notions of the day, at the same time it holds up a mirror to the world, reflecting the catastrophes that were indeed part and parcel of daily life. The world Bosch shows is a topsy-turvy one in which pleasure becomes torment and music torture. Yet it is this very reversal that allows him to exploit the po-tential of satire and create a wicked vision of the world that would not other-wise have been possible. There is no need for the world to wait for Hell. In the hands of humankind, it has already become Hell on earth. Perhaps it is signifi-cant that the the Prince of Hell is wearing a cauldron on his head that is dis-tinctly reminiscent of a globe. Given the context, the window reflected in the cauldron must surely be a metaphor for a room with no way out.

illus. page 37

This lord of the underworld, a bird-headed monster that devours humans and excretes them while seated on something that resembles a cross between a toilet and throne, prompted comparisons at the time with Tundale's vision of Hell, first published in Bosch's homeland in 1474. The punishment of car-dinal sin by a distorted version of sinful pleasure, as presented here by Bosch, was also a conventional notion at the time, though Bosch's fantastic imagery goes far beyond the norm. Naked lust, in the unwelcome embrace of a devil, is reflected, together with her grotesque companion, in a sumptuously ornate convex mirror affixed to the buttocks of another devil. In this pandemonium of earthly lust chastised, a gambler is nailed to the tavern table on which he gambled away his fortune. He is being throttled by a bird-like creature with a shield on which an amputated hand balances a dice on two fingers. Nearby, the die are cast to roll across the board of a game that has been lost for ever. In countless variations, fantasy and realism are juxtaposed in delicate equilibrium.

illus. page 40

illus. page 36

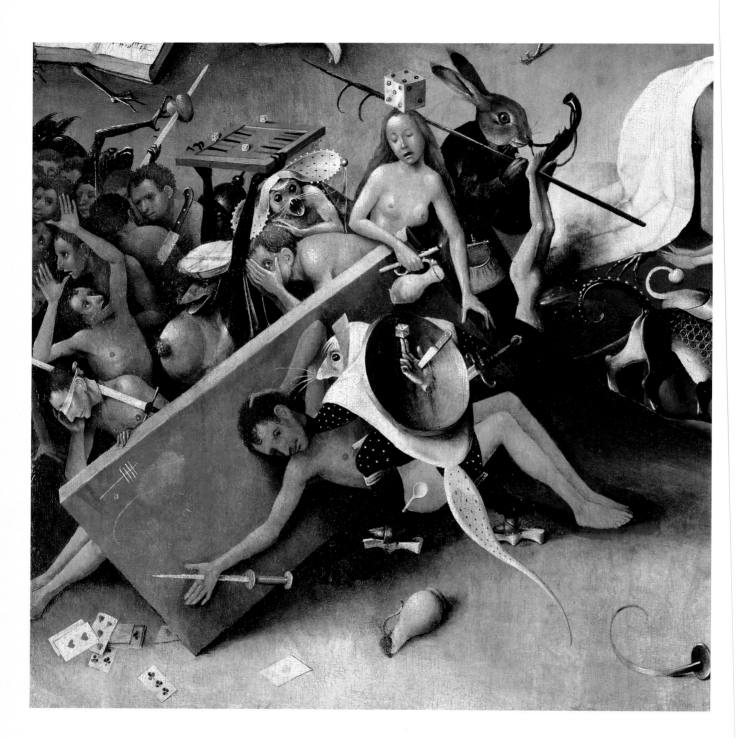

Hell: gambler nailed to the tavern table

Hell: the Prince of Hell with a cauldron on his head

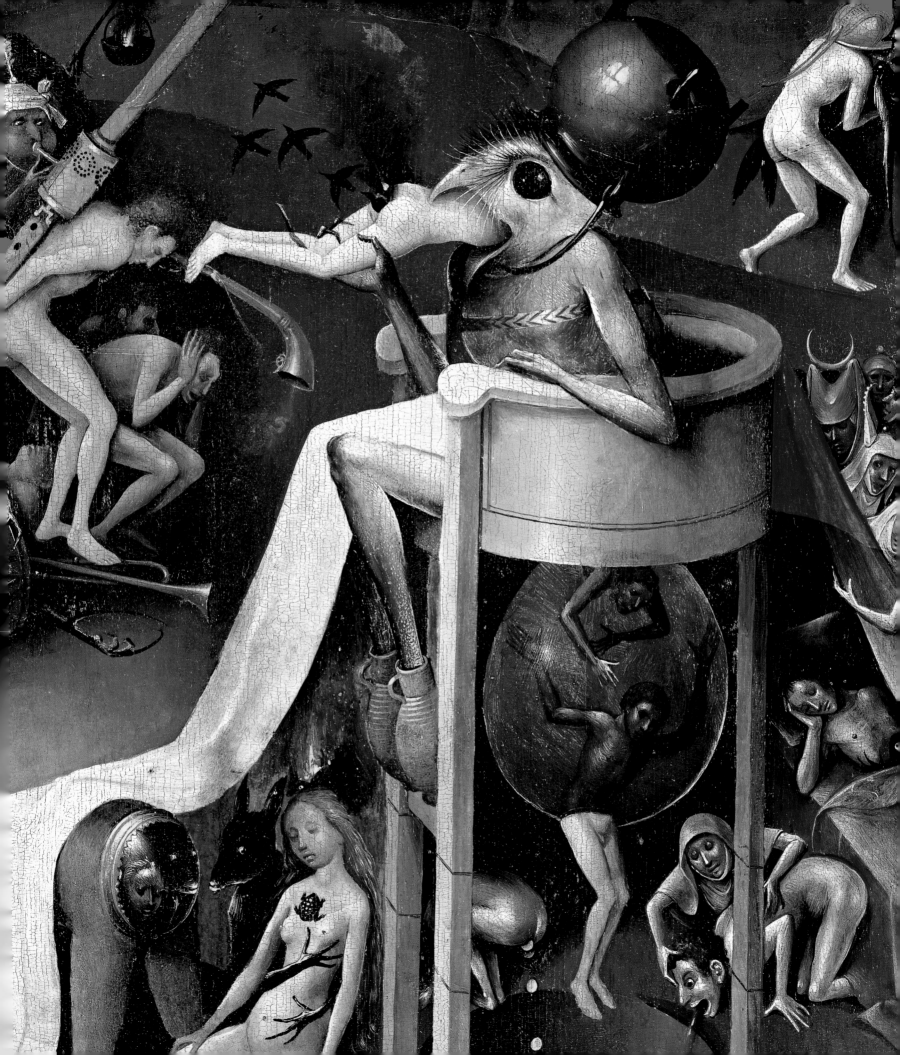

Hell is as dark as night and as cold as ice. Here, the human nakedness of the other panels becomes the cruellest torture. On frozen waterways, what was once pleasure is turned to pain. Bosch also recalls earthly discomforts when he repeatedly shows individuals vomiting and excreting. There is also an unbearable din – the torment of cacophony as punishment for misusing music as a means of seduction and temptation, as described by R. Hammerstein in his book *Diabolus in musica*. Dissonances vie with one another as indicated by the sheer size of the hugely magnified musical instruments that have been transformed into instruments of torture. Two sinners are crucified on a hybrid of harp and lute. Beside them is a howling horde of woodwind and percussion beneath an upturned hurdy-gurdy, and a hellish choir bawling notes from a score inscribed on buttocks, a place of despicable lust. The bagpipe, a dual sexual symbol, plays over the head of the 'tree man', calling devils and humans to dance, while the gigantic ears with a blade thrust between them are not only a sign of denunciation in the service of the Inquisition, but also an indication of the bodily organ that suffers the hellish music as punishment for being led into temptation.

illus. page 39

illus. page 43

The metamorphoses that Bosch creates between realism, allegory and fantasy culminate in the figure of the tree man, which also gives us an important insight into Bosch's compositional approach. We find the same figure in a drawing, known as *The Tree Man*, albeit in a natural setting. In a river flowing through what seems to be a harmlessly idyllic landscape stands a tree man with his legs in two boats. The duck-like belly is burst open, revealing a tavern with a Turkish flag. On the head of the tree man is a pitcher and a ladder with a figure tumbling between the rungs. In this whimsical composition, Bosch lets his imagination run free, turning the landscape into a hallucinatory scene. There is nothing indicative of Hell in this independent drawing, and it cannot be regarded as a preliminary study for the figure in the painting. Yet Bosch uses the figure of the tree man once again in the Hell panel, adapting him to the new iconography of Hell. It is possible that the face of the tree man is a self-portrait – an assumption supported for a long time by a number of scholars. The expression of irony and the slightly sideways gaze would then constitute the signature of an artist who claimed a bizarre pictorial world for his own personal imagination. The lean face with the conspirative gaze and long, ash-blond hair, can also be found in several of the figures on the central panel, like a discreet commentator. In the lower right-hand corner, one such figure actually looks directly at us and points a finger (p. 58).

illus. page 42

Bosch's tongue-in-cheek boldness is at its most audacious in the scene at the lower right-hand corner of the Hell panel, in the proscenium of Hell, as it were. What we see here is an accusation of guilt levelled at the church.

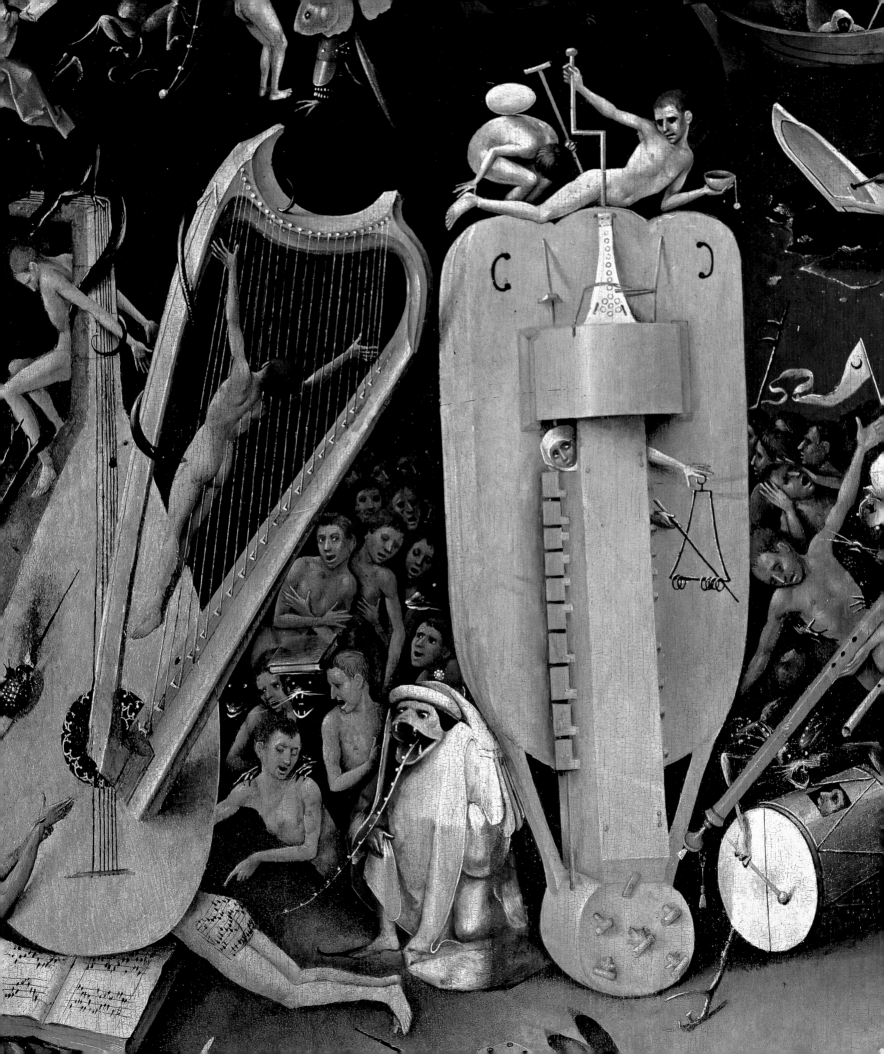

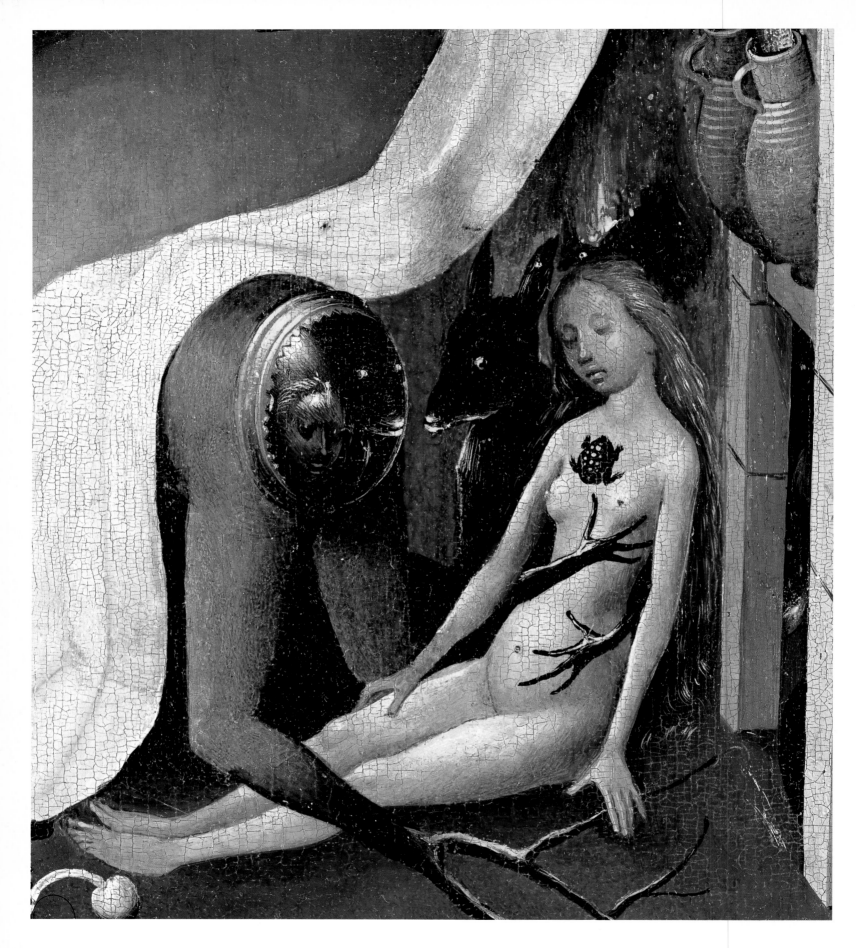

Hell: naked lust

Hell: pig wearing a nun's veil

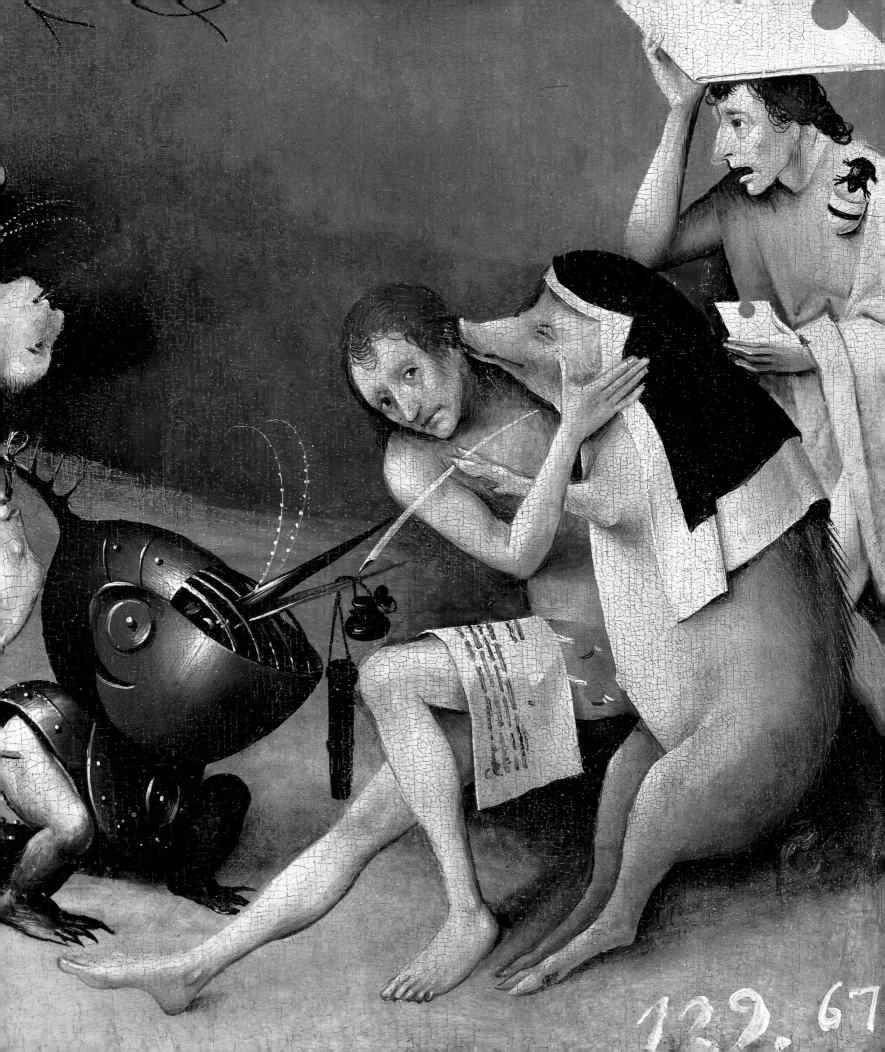

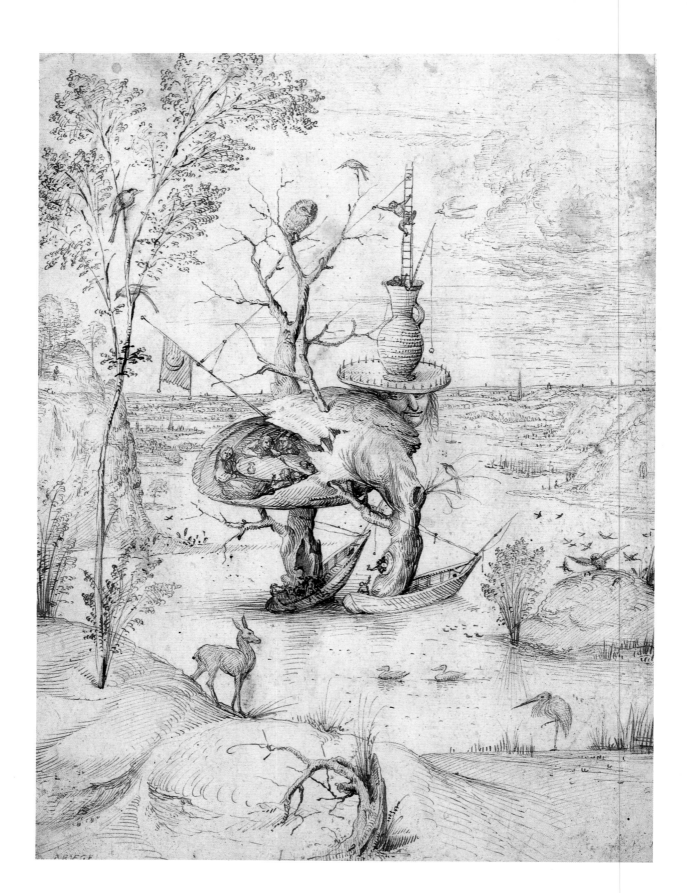

The Tree Man,
drawing, Albertina, Vienna

Hell: The Tree Man

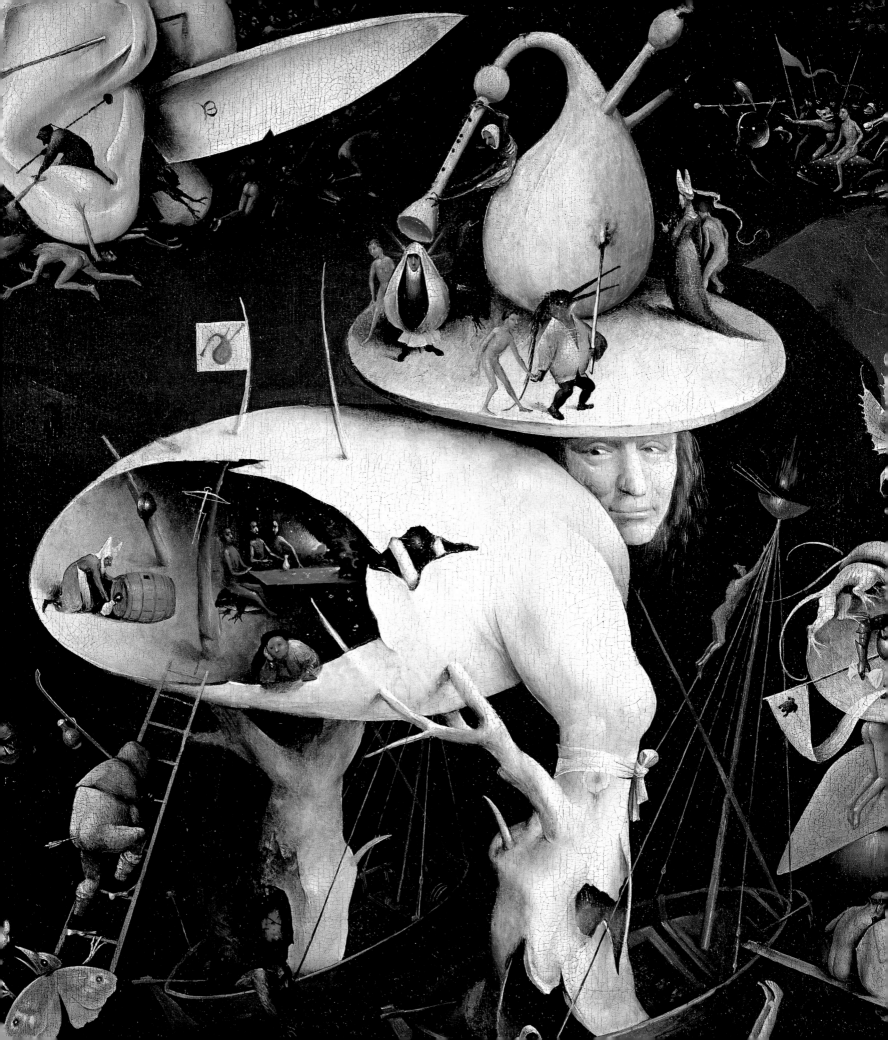

A fat pig wearing the veil of a Dominican nun is seducing an unwilling man with her kisses in a bid to persuade him to sign a contract bequeathing his fortune to the church. An assistant is ready and waiting with the seal for the contract. A second assistant, concealed in a suit of armour with a foot dangling from it as the emblem of the professional beggar, proffers the inkpot for the signature. This is not a depiction of one of the hellish punishments, as in the nearby scenes. If at all, it is a pointer to a sin committed by the church, revealed by the fact that it has brought no advantage. There is no reason to assume that the sinner did not give the nun his signature. In spite of the promise of salvation, he has ended up in Hell for his sins. Only changing his way of life could have prevented that. This painted commentary would appear to presage the Reformation controversy about faith as opposed to the benefit of good deeds for salvation. The only people who could laugh about it were those who were above these things and could defend themselves against the church – including, as we shall see, the owner of the triptych.

illus. page 41

Bosch's art reaches the pinnacle of its perfection where there is nothing left to tell in terms of iconography. The night sky is lit up by huge fires that are reflected in the water and shine through a city gate, illuminating a road where a crowd of refugees is seen wandering aimlessly through the night, while enemy armies are already approaching the next town to put it to the torch. This ghostly scene is almost unparalleled in Netherlandish art, with the exception of Bruegel the Elder. Paradoxically, it thrives on the realism of personal experience that the artist tranposes to his work in an unfettered riot of colour and light in the depth of night. Such hell-fires did indeed rage in Bosch's own world.

illus. page 45

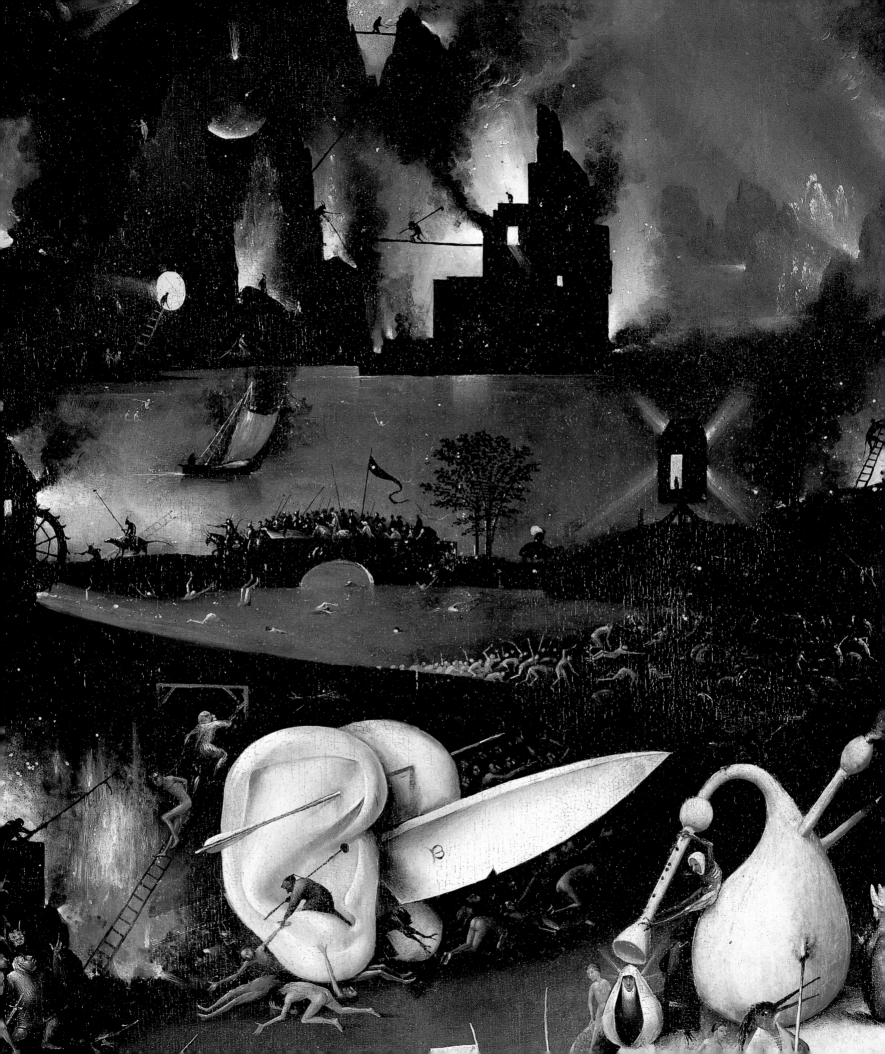

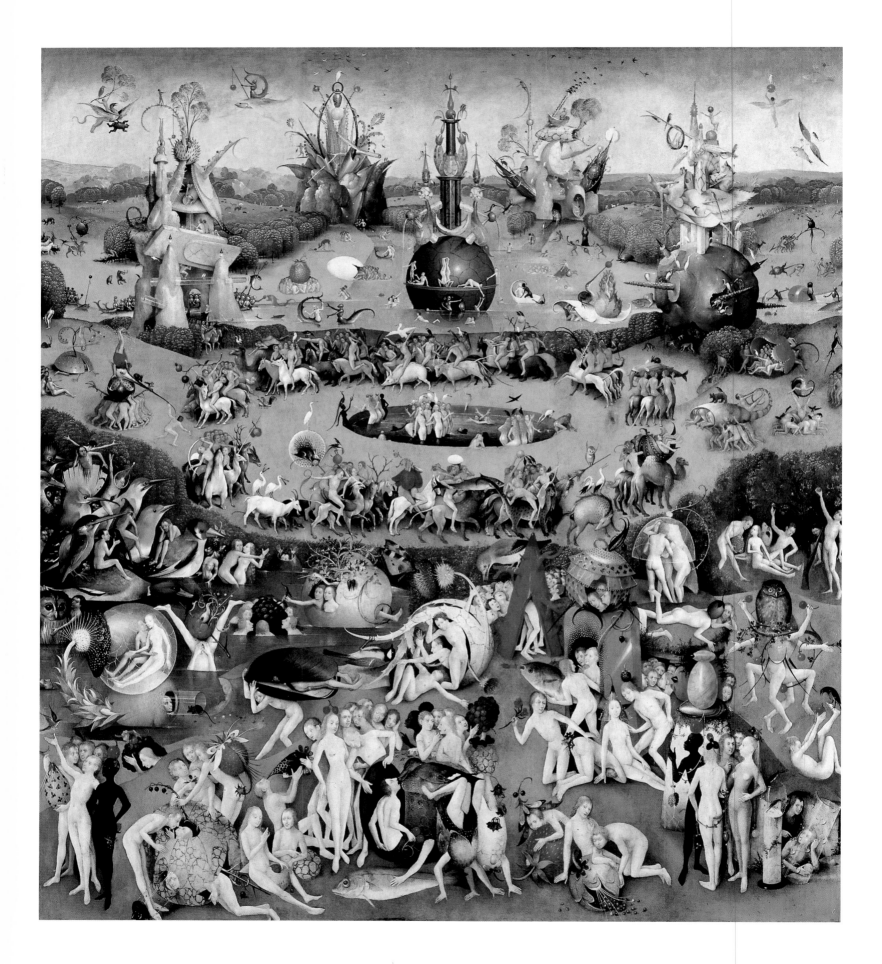

The central panel so fascinated viewers in Bosch's own lifetime that it was copied from early on. While it does not depict the Paradise portrayed in the left-hand panel, it does not show the earthly world either. What could be the setting for this scene of naked people indulging in sexual play, riding on birds or creeping through strawberries? In this counter-image of civilization, humankind lives in nature and is at the same time a part of nature. The landscape of Paradise in the adjacent panel is continued here. Yet, as anyone familiar with the Bible would know, the human race did not people the earth until after Adam and Eve were driven out of the Garden of Eden. In other words, the artist prevents the spectator from allocating the scene in the central panel to any time or place in the Biblical history of the world. Bosch was appealing to the viewer's imagination, calling for everyone to undertake his or her own personal interpretation of this panorama of repeated motifs, free of any notion of a time sequence linking the three pictures on the inside of the triptych.

A sumptuous garden, stretching all the way across the world, is full of people joyfully engaged in the pleasures of the flesh and moving as freely in the shimmering waters and sunny meadows as the animals that frolic with them. They do not possess the self-consciousness that would alienate them from this natural idyll. In the lower left-hand corner, in a group representing all the races of the world, a white figure, unabashedly naked, stretches out an arm towards the first couple in the neighbouring panel, as though to say to his companions: "This is where we all come from." Towards the background, in the middle of the picture, a huge, blue, finely-veined, globe-like fruit pod rises from the water in which an embracing couple is swimming, and, on the shore,

illus. page 48

illus. page 49

there is a throng of people crawling back into a broken eggshell as though seeking to reverse their origins. In the blue sphere, the erotic play continues behind a window in the centre. There, a man fondles his partner's genitals while another turns his buttocks towards her. Already, we are caught in a teeming labyrinth of motifs so numerous that merely recounting them is to no great advantage. In the pond, a fish-like creature in armour appears to be jousting with a mermaid in a parody of courtly mores. The artist lures us into the paradise described in the Book of Genesis as a place over which man was to have dominion, be fruitful and replenish the earth. The contradiction in this picture is the fact that we see Paradise populated.

Towards the middle ground, there is a clearing with a round spring in which the most seductive of women display their charms, while men on horses, unicorns and exotic animals, some in acrobatic poses, ride around the pool

illus. page 19

as though driven by their own desires. They seem to be parading specially for

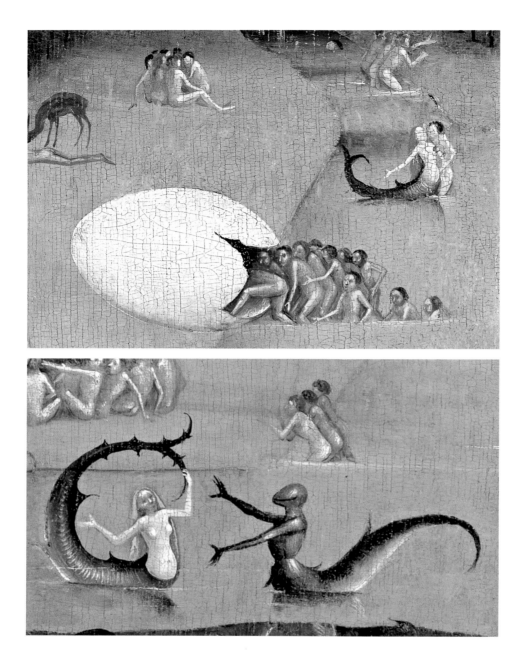

the women, who are not paying full attention to them. The beauties in the pool have peacocks, ravens and fruit on their heads. The pond behind them divides into four waterways around the emblem of cosmic fertility and, on the shores, are coral-like formations with biomorphic protuberances towering skywards. These signify the four regions of the world that constitute a continuation of this populated garden (p.88). In the foreground, where there is no perspectival order, the viewer's gaze wanders from motif to motif in a confusion of anecdotes that surpass one another. All sense of proportion seems to go awry, with gigantic yet life-like songbirds and ducks on which tiny people are riding, swimming in the water or eating huge fruit too big for one person.

illus. page 50

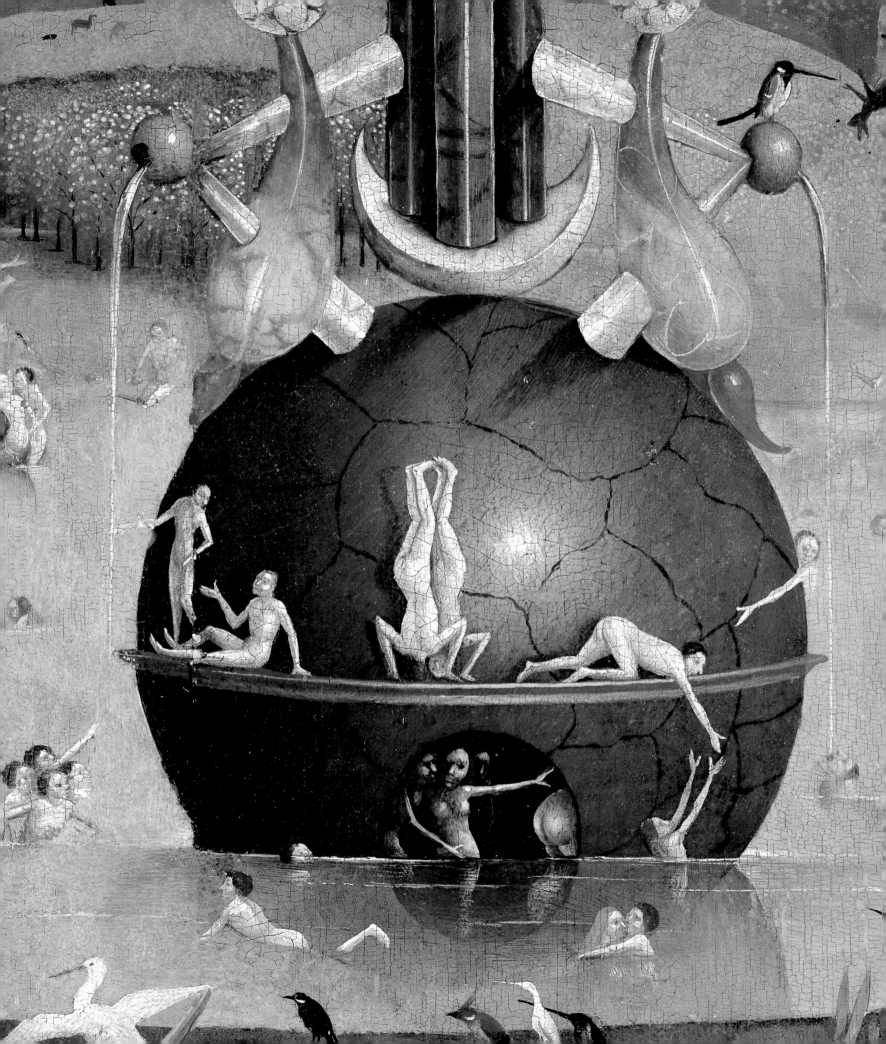

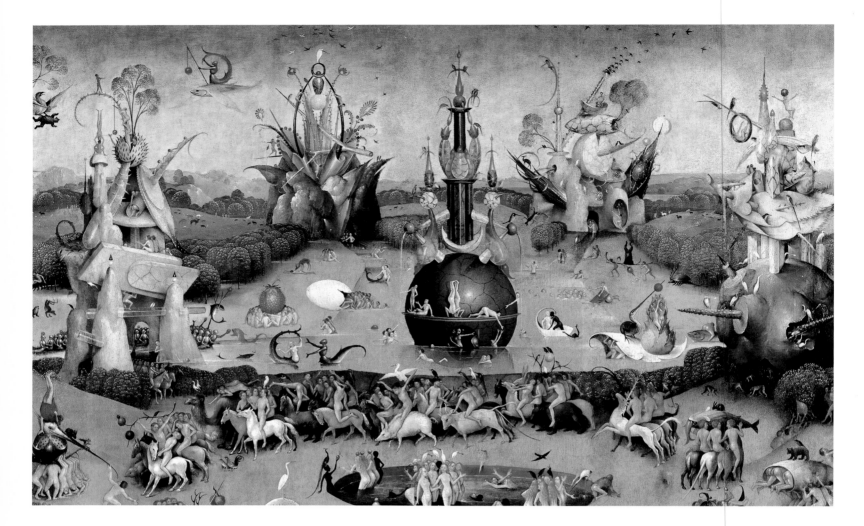

The four regions of the world

following pages:
The four regions of the world (details)

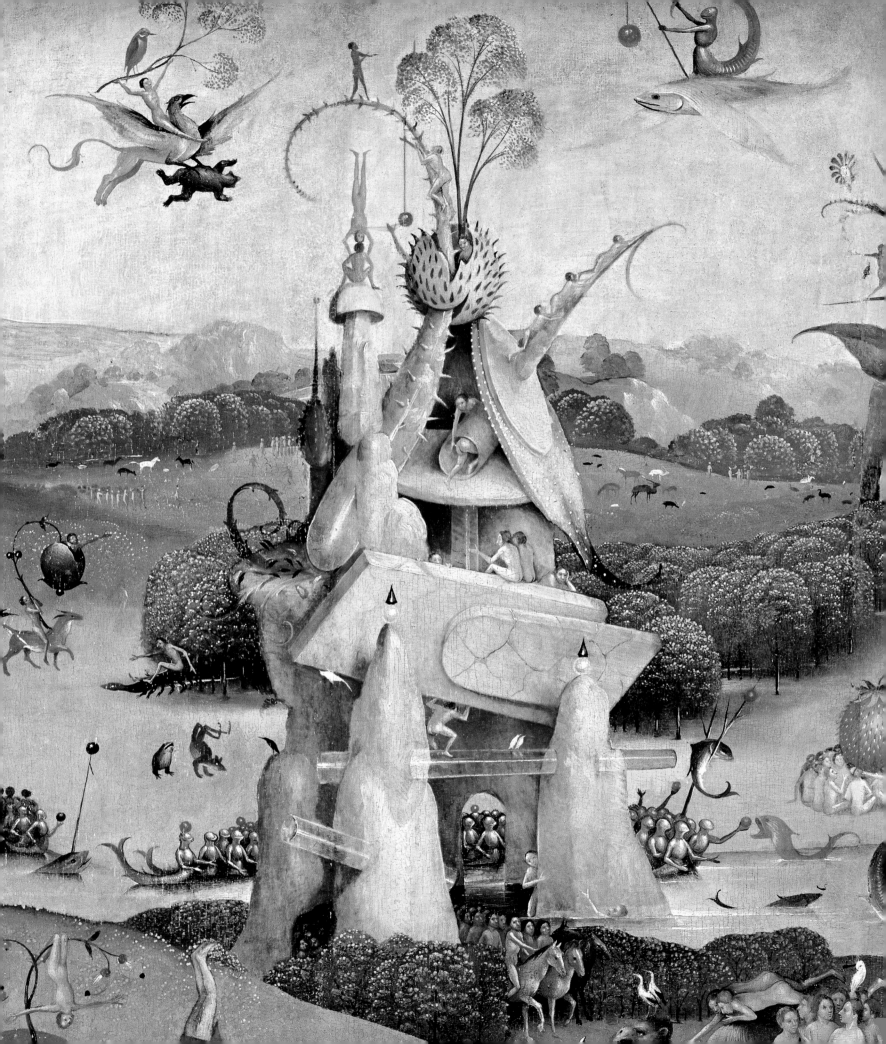

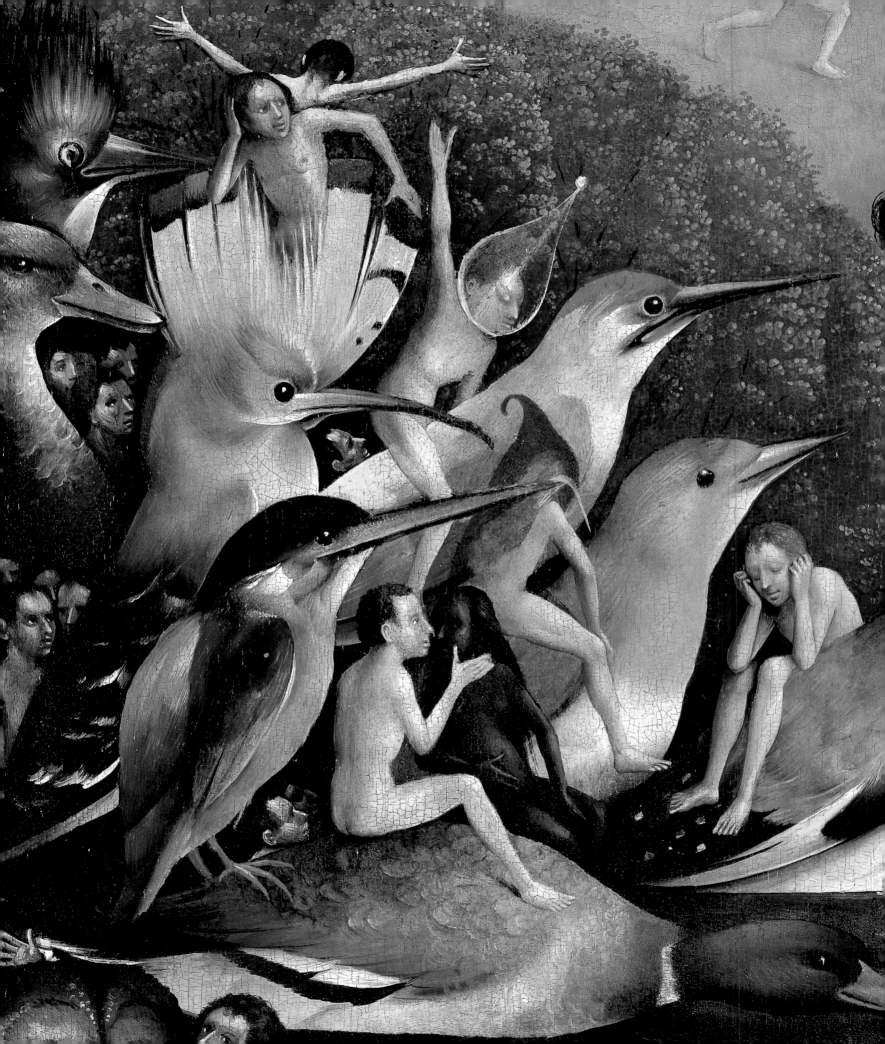

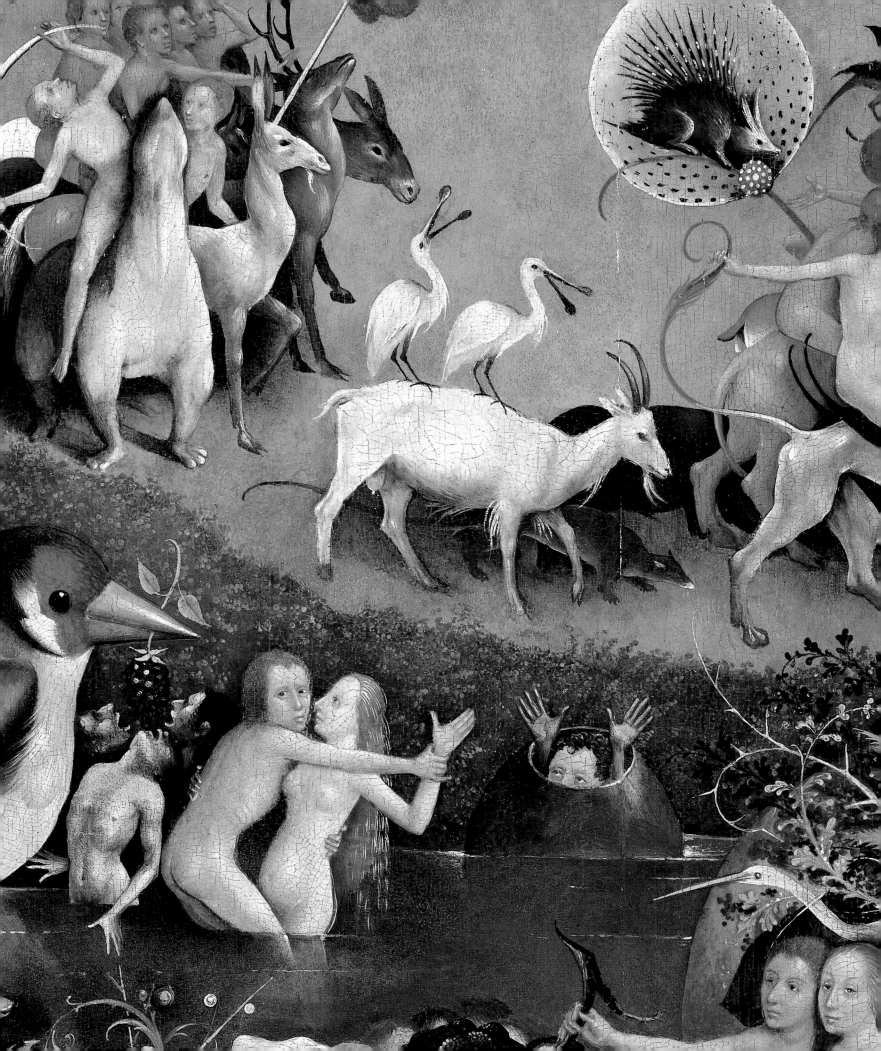

Not only do we see people acting in unfamiliar ways here; nature itself is different – familiar yet unfamiliar, neither natural nor fantastic.

The familiar forms of nature are suspended in the imaginary nature of Bosch's notion of Paradise. There are birds in the water, and fish on dry land and in the air. We see birds feeding people and fish being carried by people or growing wings. Humans crawl into molluscs, crustaceans and shells, and push their way between the legs of birds. The symbiotic relationship between man and animal, and between man and plant, as symbolised by the huge fruits from which humans and animals eat, is a vision of humankind living in *illus. page 55* harmony with nature in a way that defies reality. This painting is in a state of permanent 'becoming,' and the only thing that is absent is death. The exuberant fecundity is symbolised by fruit pods and eggshells and by the mussel, into which a naked couple has crawled. The strawberries and cherries in abundance *illus. page 15* have a similar significance and are devoured with an appetite as insatiable as that of young birds being fed, open-beaked, in their nest. Where there is no *illus. page 53* sin, the fruit does not signify forbidden sexual desire, but the natural fertility served by the pleasures of the flesh. Food is a predominant motif in this picture, whereby eating and copulating both represent the nurturing of life that prevails in this Paradise. Death did not enter the world until the Fall of Man.

It should be pointed out that there are no children in this Paradise. People seem to crawl out of the fruit and plants fully formed, as though spared the labours of childbirth. By denying the negative aspects that burden earthly life, Bosch creates a vision of unspoilt and immortal existence. It is as though Paradise had always been a necessary vision for humankind as a means of explaining daily reality in terms of the loss of a Golden Age. Nature, too, is idealised in this scene, and growth is as unthreatened as ripeness and beauty. Yet the people in this Paradise are not only ageless, but lacking in individuality. Their doll-like bodies are so devoid of individual traits that they might even be seen as naked souls. Their corporeality is so effortless – and thus so alien – that even their acrobatic acts of erotic play seem childlike. We are looking at a human race we do not know. This is not an image of redemption and death overcome, but a utopian vision of a world that never existed.

No sign of discord mars the idyll; yet looking more closely, we doubt the innocence of the scene. A man clutches a huge owl as though seeking to prevent it from flying at night and thus hindering night itself. Beneath a huge, trans- *illus. page 56* parent amniotic bubble in which a couple is about to make love, a man stares entranced at a mouse whose impurity threatens to poison the self-adulating beauty of the scene. The animal has walked into a glass cylinder pushed into a large fruit. The few glass cylinders in the picture are technical, man-made products and, as such, contradict the organic fertility of paradisical nature.

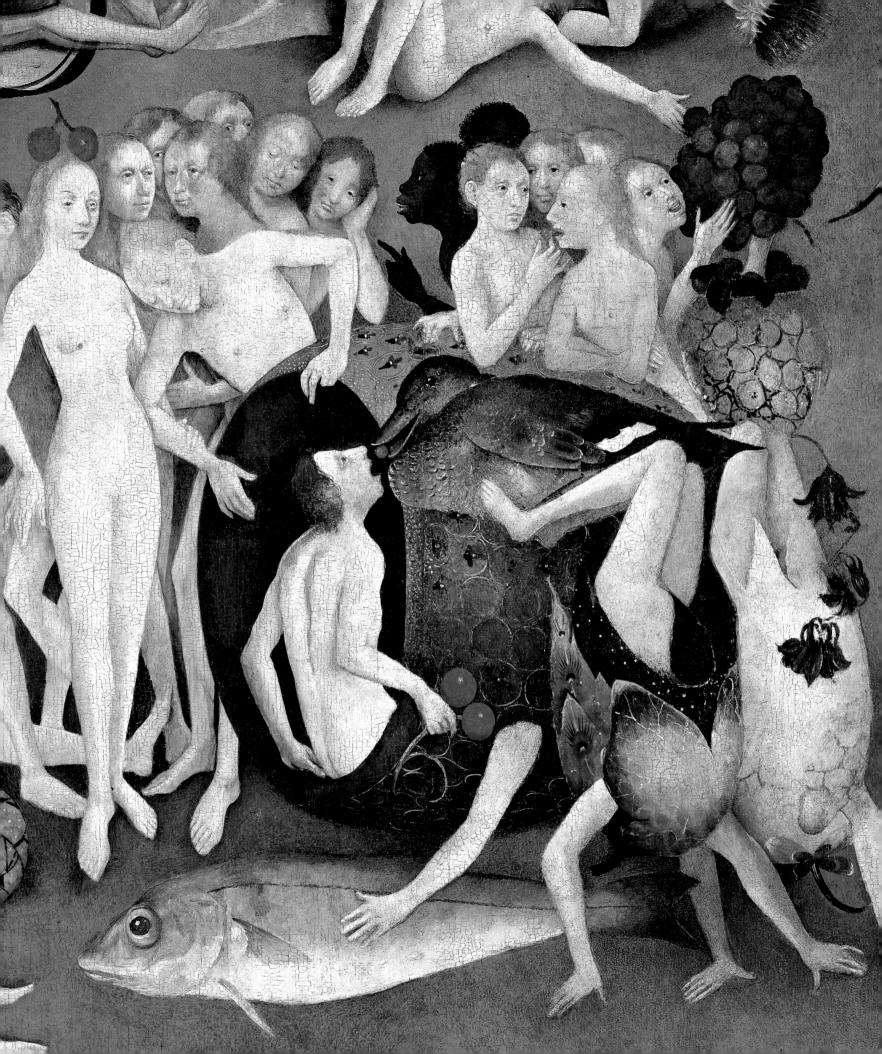

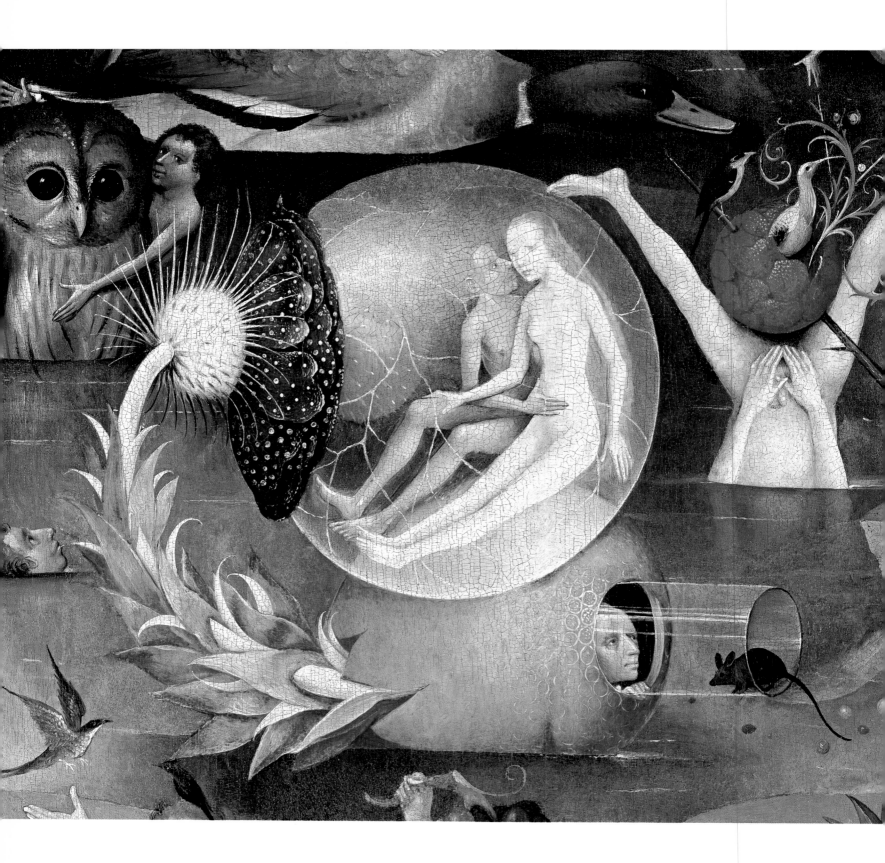

Bosch may have been referring here to the test tubes used by alchemists in their quest to distort the laws of Creation. If so, this could be read as a critical commentary accusing humankind of sinfully imitating nature and thus insulting God's divine Creation. Natural fertility was a very different matter from the chemical transformation of elements in the laboratories of the alchemists. Such practices are mocked by the thoroughly realistic portrayal of a glass cylinder with an ebony base which looks so remarkably out of place in the lower right-hand corner.

illus. page 58

Behind a large bubble-glass vessel, a blonde woman rests her head on her hand in a gesture of melancholy, her mouth firmly closed and an uneaten apple in her other hand. A man, the only clothed figure in the picture, looks out at the spectator, pointing to the woman like a silent commentator. It is thought that this figure, like the tree man in the Hell panel, is in fact a self-portrait of Bosch. He may be in the guise of Adam, observing Eve before the Fall. Yet no matter how this controversial scene is interpreted, it does scratch the otherwise perfect surface of the fable. For it is here that consciousness comes into play – an awareness of the difference between good and evil that, according to the Bible, did not exist before the Fall of Man. This construct gave the artist free rein to portray the fictitious paradise as it may have been regarded in the collective imagination of his day. For the spectator, the appeal of this work lay in the fact that Bosch constantly blurred the boundary between the real and the imaginary. Bosch's portrayal of nature surpasses anything produced before, and he displays a rare technical brilliance in his depiction of the horses, pigs and cats around the pleasure pool, to name but one aspect. He portrays imaginary creatures such as griffins and unicorns with the same painstaking realism. In the background, his imagination triumphs in the flying fishes and anthropomorphic butterflies that appear in the sky above the hybrid stone formations. The ambivalence of Bosch's visual syntax exceeds even the enigma of content, opening up that new dimension of lyrical freedom by which painting becomes art.

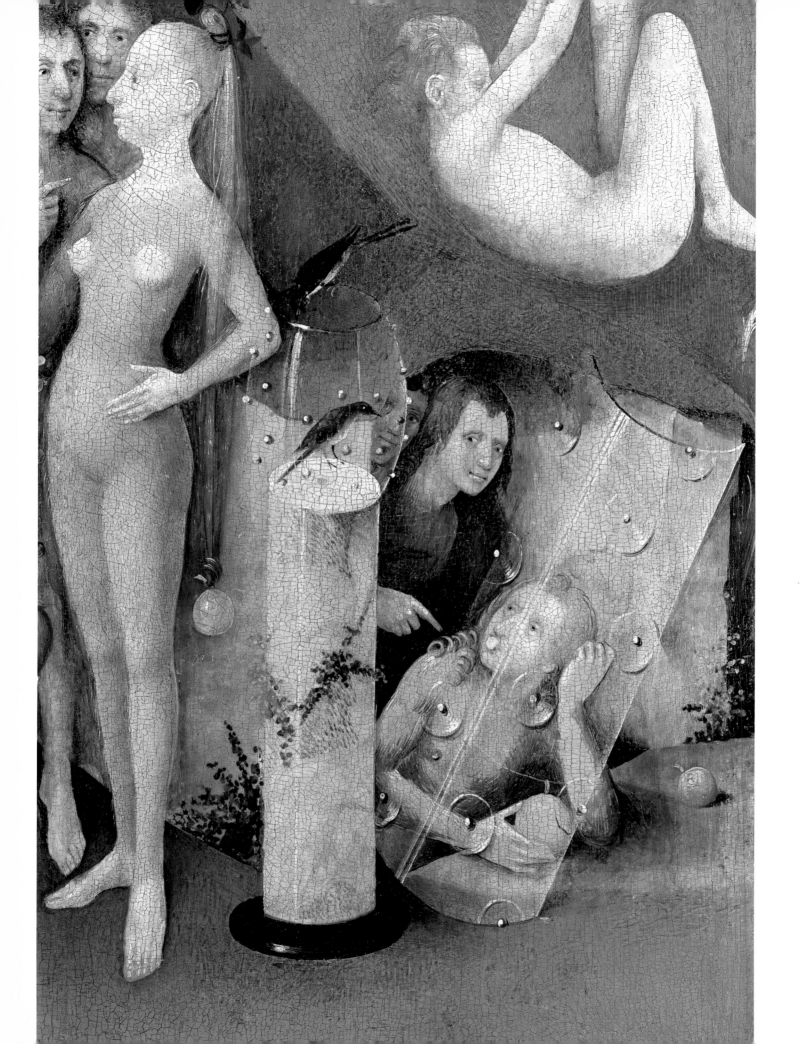

illus. page 94

Visitors to 's-Hertogenbosch today can scarcely imagine the former importance this sleepy town on the plains once enjoyed as a trading centre in the Rhine-Maas delta. Only the St Janskerk, for which Bosch once painted altarpieces for the High Altar and for the Chapel of the Brotherhood of Our Lady, recalls this bygone age, though the iconoclasts of the Reformation largely destroyed the inventory. The system of canals and waterways also recalls its former status. In Bosch's lifetime it was the third largest town in Brabant, after Antwerp and Brussels. Many leading figures would break their journeys here on the way to Flanders or the German Reich. The Knights of the Order of the Golden Fleece convened here on numerous occasions. Emperor Maximilian visited the town, and his son, Philip the Fair, regent of the Netherlands, wintered here in 1504 with Hendrik of Nassau, on the way to the latter's marriage ceremony. Hendrik of Nassau was later to become the owner of the *Garden of Earthly Delights*, and Philip the Fair personally commissioned an altarpiece (p. 74) from Bosch while he was there. In 1496, the city had a population of 17,280. A few years later, 930 monks and nuns are recorded as living here. At the time, 's-Hertogenbosch had more than thirty churches and chapels.

Jheronimus Anthonissen van Aken, who later took the name of his home town as his *nom de plume*, was born here around 1450 into an established family of painters and craftsmen. The laconic reports of his life provide only an outline of his municipal existence, without mentioning his art and his international patronage. Art literature as practised in Italy at the time was still an unknown genre there. The family home, where he appears to have continued working even after his marriage, was on the east side of the market place. In June 1481 Bosch married Aleid van Meervenne, daughter of a wealthy merchant family, and moved into the house of Inden Salvatoer on the more prestigious north side of the marketplace, where the larger houses of the social elite were located.

A printing press is documented here in 1484, making 's-Hertogenbosch one of the earliest centres of this new industry. In the year 1484, a publisher from Nijmwegen printed Tundale's vision of Hell, which is used as a source in Bosch's work, especially on the Hell panel of his *Garden of Earthly Delights* (p. 35). Around this time, Erasmus of Rotterdam, who would later become the Prince of the Humanists, (p. 110) was a student at the Latin school of the Brothers of the Common Life. The work of Bosch, which he could see every day, did not strike a chord with this classically minded scholar.

Almost everything we know of Bosch's life is related to his membership of the famous Brotherhood of Our Lady. The Brotherhood included members of

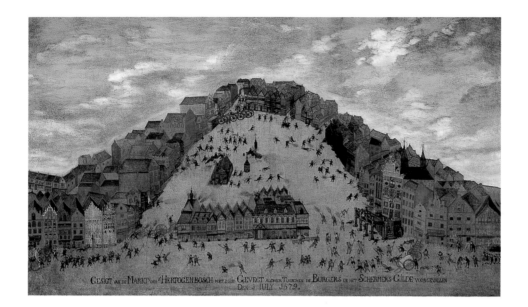

Jan van Diepenbeck
Marketplace in 's-Hertogenbosch, 1579
Noordbrabants Museum,
's-Hertogenbosch

the patrician class and constituted an elite 'like a lily among thorns' in the close-knit urban community. Nine annual feasts were held, involving processions with an image of the Virgin Mary and passion plays featuring devils as comic figures. Bosch enroled in the Brotherhood in 1486/87 and was soon a fully sworn member. In July 1488, the Brotherhood's 'Swan Banquet' was held at his home for the first time. In 1510, on a similar occasion, on the fourth Sunday of Lent, following early mass in the chapel of the Brotherhood, the members went "to the house of Jheronimus van Aken the painter who calls himself Jheronimus Bosch." In 1516, his funeral mass was held. When this date was recorded half a century later in the register of the Brotherhood, it bore the comment *insignis pictor* (famous painter). His art production and his reputation on the European art market can only be reconstructed on the basis of scattered and coincidental information.

In 1521 three paintings by Bosch are mentioned as being owned by the Venetian cardinal Grimani. After 1523 the Portuguese diplomat Damiao de Goes purchased three religious paintings by Bosch on the art market. By that time, Bosch was already so famous that there were forged copies in circulation. We know this from the Spanish humanist Felipe de Guevara, who owned six paintings by Bosch. They may possibly have been purchased by his father, Diego, during Bosch's own lifetime when he was an advisor to the court in the Netherlands as a representative of the Spanish crown. In his *Commentaries on Painting*, written around 1560, Guevara chided the counterfeiters who, in the decades before, had forged this "successful painting ... by painting monsters and many imaginary things in the foolish belief that this alone sufficed to emulate Bosch. In this way, many pictures of this kind were

created and signed with his name which were in fact based on deceit." Their only credibility was the artificial patina created by exposing them to smoke, since "they were hung in the chimney to make them look old." This is a remarkable report, indicating that the work of Bosch was forged because it could not be continued. Bosch's fame is rooted in an acceptance of his art as an exception. Even at the height of Mannerism, his was an œuvre that defied historical classification and ended once and for all with the death of the artist.

The Rotterdam exhibition of 2001 made it abundantly clear that Bosch's own works were delicate, precious and unique, while those who copied him, just as Guevara writes, were all too willing to sacrifice painterly quality in their bid to surpass Bosch in outlandish originality. In their roughshod approach to Bosch's subtle iconography, in their manipulation and exaggeration of his motifs, it is evident that the provocative nature of this kind of painting had lost its edge. Where Bosch had tread with care, his emulators rushed in, seeking only to pander to a fad. Indeed, the fashion for works in the style of Bosch took on dimensions of mass production that dwarfed the limited œuvre of Bosch himself. Recent analyses of the wood used have shown that some panels formerly ascribed to the master must have been painted long after his death. These misattributions include the *Crowning with Thorns* in the Escorial, the *Ecce Homo* in Philadelphia and the *Birth of Christ* in Cologne. It is even possible that Bosch-style themes were invented later and still legitimised as copies after Bosch in order to satisfy an insatiable demand.

In his *Commentaries*, Felipe de Guevara warned the uninitiated against regarding Bosch merely as an "inventor of monsters and chimera" that violated "the bounds of nature." He wrote in defence of the beauty and poetic licence in Bosch's work, comparing it with a comic genre of Ancient painting known as *grylloi*. Indeed, this particular Guevara text was taken almost verbatim from the writings of Pliny, who had described the Greek artist Antiphilos as the father of a distinctive satirical genre of painting. Guevara, who was born during Bosch's own lifetime, makes the bold move of comparing Bosch with an artist of classical antiquity in defence of his inventive originality within the scope of traditional iconography. He sought to prove that Bosch, given his late medieval subject matter, had been the first to conquer the freedom of art.

Siguënza (p. 8) makes a similar comparison with poetry in pointing out that the brush and the pen are both in the service of art. He associates Bosch with an early modern Italian writer who broke away from all known styles of poetry to create "a comic style that he called macaronic." Though Siguënza knew him only by his pseudonym Merlin Cocaio, the poet in question was in fact Teofilo Folengo (1491–1544), a monk whose burlesque epic *Baldus*, a

tale of knighthood ending in Hell, is written in an invented jargon of Latin-sounding Italian stylised to a form a rustic literary language known as macaronic. In other words, Folengo elevated a hybrid and non-classical style to an art form. By making this comparison, Sigüenza defends Bosch against the aesthetic norms of the Renaissance, which he did not match, maintaining the Bosch had never intended to do so. Bosch, he wrote, had not sought to emulate the macaronic poet, whose works appear to have been written later anyway, but had had his own reasons to transform a satirical style into a serious art form.

All these interpretations presuppose the emergence of a theory of art that did not exist in Bosch's world. Through the back door, as it were, they introduce Bosch's painting into a discourse of which it was never a part, and make his non-classical œuvre a classic in art. Given that we have no contemporary sources on Bosch's art, only the œuvre itself can give us an insight into Bosch's concept of painting, which he developed more or less alone. In doing so, the poetic freedom he claimed for himself was not his only strategy. His contradictory form of realism is another aspect of his painting. It is a critical realism which, at the time, was the preserve of writers. Bosch gazed into the mirror of the world with a mix of curiosity and disappointment. It is no coincidence that the Temptation of Saint Antony, the hermit heroically resisting worldly illusions and deceits, was the most frequently addressed theme in his œuvre. Indeed, so successful was his exploration of this subject matter that important patrons repeatedly purchased works of this kind from him, as though to arm themselves against the temptations of the world.

Bosch's own world can be found in the motifs and settings of his religious paintings. In *The Mocking of Christ (Ecce Homo)* now in Frankfurt, we see the figure of Christ presented to the baying mob and the councillors of a northern European city. In his *Marriage at Canaa*, now in Rotterdam, we witness a contemporary banquet that appears to document the 'Swan Banquet' of the Brotherhood of Our Lady hosted by Bosch in 1488. Some of the pictures have a popular touch referring to commonplace sayings and proverbs. The round *Stone Operation (A Cure for Folly)* bears an inscription in exaggeratedly ceremonious calligraphy that reiterates a popular idiomatic saying. The patient is having an operation carried out by a quack doctor to remove the 'stone of folly' from his head. For the first time, the spectator could laugh about a painting instead of gazing at it in pious awe. Bosch offered a new perception of the painted image as a commentary on the world. From here, it was but a small step to the imaginative imagery of the *Garden of Earthly Delights* (p. 87).

The Vagabond in Rotterdam calls for an allegorical interpretation, even though it is clearly saturated with observations from real life. A man is erring through a world in which he is not at home. He has been turned away from

illus. page 65

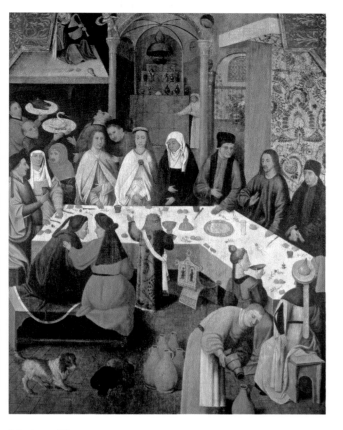

The Mocking of Christ (Ecce homo)
Städelsches Kunstinstitut, Frankfurt am Main

Marriage of Canaa
Museum Boijmans Van Beuningen, Rotterdam

an inn, where a dog is barking at him as he leaves. The silver-haired man looks back at the place from which he is being driven. Here, human existence in the world is portrayed in general terms by way of example of the growing numbers of vagabonds and beggars. Unlike the pilgrim portrayed by Bosch on the outer panels of the Viennese *Last Judgment* altarpiece (p. 74) in the guise of St James, the vagabond has no sure destination where he might expect salvation.

In this respect, it is significant that *The Vagabond* was once part of an ensemble. Traces of where the wings opened, dividing the panel in two, can still be seen at the shoulder area. It must have formed the outer wing of a secular triptych in much the same way as the figure of the vagabond in the

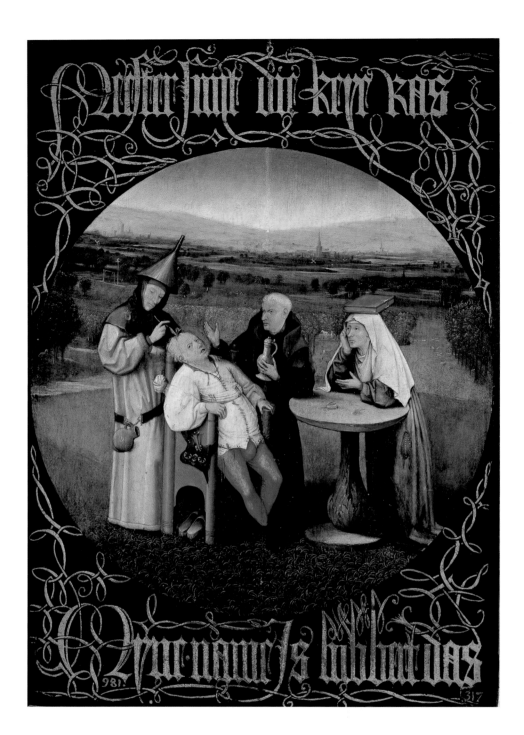

Stone Operation, c. 1490
Museo Nacional del Prado, Madrid

outer view of *The Haywain* (p. 86). The octagonal trimming and round inner frame are later alterations of a kind not infrequently made to the works of Bosch by later art collectors to accommodate changing aesthetic tastes. It is possible that it was part of a triptych featuring the *Ship of Fools,* now in the Louvre, along with *The Glutton,* now in Yale, and the *Death and the Miser,* now in Washington, which are clearly pendants. As Bernard Vermet argues in the catalogue of the Rotterdam Bosch exhibition, these may have been the

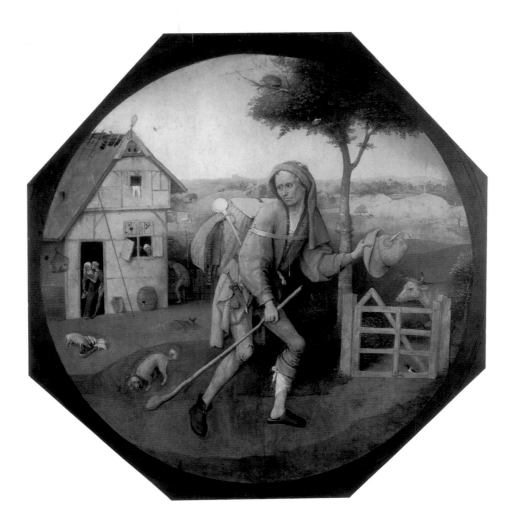

The Vagabond
(originally an outer panel
of a triptych which has
since been lost)
Museum Boijmans Van
Beuningen, Rotterdam

former inner panels. With his pictures, the artist created a market for satirical criticism of the foolishness of society and the sins of the individual, often based on literary models.

The *Ship of Fools* in the Louvre is particularly indicative of the way Bosch vied with the moralising literature of the day. No matter how realistic each individual motif in this portrayal of carnival revelers may be, the subject matter is an abstract idea condensed into a verbal image ('Ship of Fools'). For chronological reasons, its literary source is unlikely to be Sebastian Brant's long allegorical poem of the same name (*Das Narrenschiff*, 1494), though it is certainly the most direct literary parallel. In spite of the title, the picture focuses primarily on the metaphor of the 'mirror of fools' that is an important key to Bosch's œuvre as a whole. Johann Geiler von Kaiserberg, a preacher who gave a series of sermons based on Sebastian Brant's poem in Strasbourg in 1498, compares it with a "mirror of moral truth reflected in figures of speech and parables." The 'inventor of this mirror,' that is to say

Brant, did not appeal to vanity but to wisdom. Similarly, Bosch also saw himself as the 'inventor' (*fictor*) of an art with a highly personal concept that revealed the illusions he painted with such pleasure. Like his literary contemporary, he juxtaposed his allegory with realistic quotes from a current 'behavioural iconography' that D. Bax traced in Dutch sayings and proverbs.

Bosch's paintings are text-like or linguistic in the sense that they are coded in much the same way as a text. Bosch may well have been inspired by the medium of print or by the marginal illustrations in textbooks, but he was the first to transpose this repertoire to the 'serious' medium of painting, thereby creating an entirely new function for painting in the art market. It is interesting to note that Bosch used drawing not only as part of the process of painting, but also as an independent medium imbued with a profoundly personal mode of spontaneous expression. The fact that he was the first artist to leave behind a body of original drawings strongly suggests that his impromptu pen and brush drawings were collected even then. In his drawings he not only captured fleeting observations of his urban environment but also made excursions into the open landscape to capture directly life's cosmos of creatures that hop and crawl and fly. Yet even in that he was not content simply to document what he saw, but extended his observations into the realms of the imagination. Inner and outer images mix when the eye merely supplies the raw material for the work of his profound fantasy. In a pen and bistre drawing now in Berlin, the viewer can admire the superb mastery of line with which natural details of trees and birds are portrayed. On the bare branches of a dead tree with an owl perched in its hollow trunk (Bosch must have observed it by night), various different birds screech and flap their wings. Then we discover that the trees have human ears and that human eyes are watching us from the field. Gone is the innocence of the gaze with which such contemporaries as Hans Memling and Gerard David catered for urban society's love of nature. When nature takes on anthropomorphic traits in Bosch's ever watchful eye, it is revealed as a realm of danger and violence in which there can be no unspoilt counterimage of civilisation.

Yet the greatest surprise of all lies in the fact that this landscape does not signify what it appears to portray but is instead a coded metaphor of Bosch's home town, whose name can be interpreted as a rebus-like puzzle. For 's-Hertogenbosch quite literally means "the forest (*bos*) of the duke (*hertog*)," while it also contains elements pertaining to the eyes (*ogen*) and ears, thus lending itself to punning. A Latin phrase, apparently written by Bosch himself on the upper edge of the page, admonishes the small-minded who always use existing clichés (*inventis*) and never invent anything themselves (*numquam inveniendis*), as though the artist sought to defend himself against criticism of traditionalists. The artist's reference to his own pseudonym is obvious.

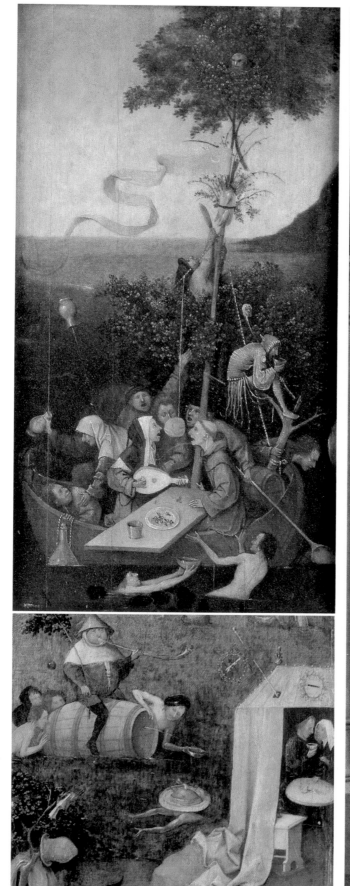

Ship of Fools
Musée du Louvre, Paris

The Glutton
Yale University Art Gallery,
New Haven: Gift of
Hannah D. and Louis
M. Rabinowitz

Death and the Miser
National Gallery of Art,
Washington

Originally inner panels
of a triptych which has
since been lost.
(See also page 65)

Equally obvious is the reference to a contemporary saying that linked Bosch with the name of the town, as pointed out by Jos Koldeweji in the Rotterdam exhibition catalogue. The proverb Bosch refers to means that it was better to see and hear (i.e. to be silent) if "the forests have ears and the fields have eyes." Combined with the name of the town, this is a subtle indication of Bosch's philosophy of life and survival strategy in dangerous city life. Suddenly, the dead tree in which the owl and the fox seek shelter takes on a new meaning. While the birds in the branches screech loudly and flap their wings, drawing attention and thus danger to themselves, the owl and the fox hide silently within.

Stamp made with the
's-Hertogenbosch city seal
1534/35
Noordbrabants Museum,
's-Hertogenbosch

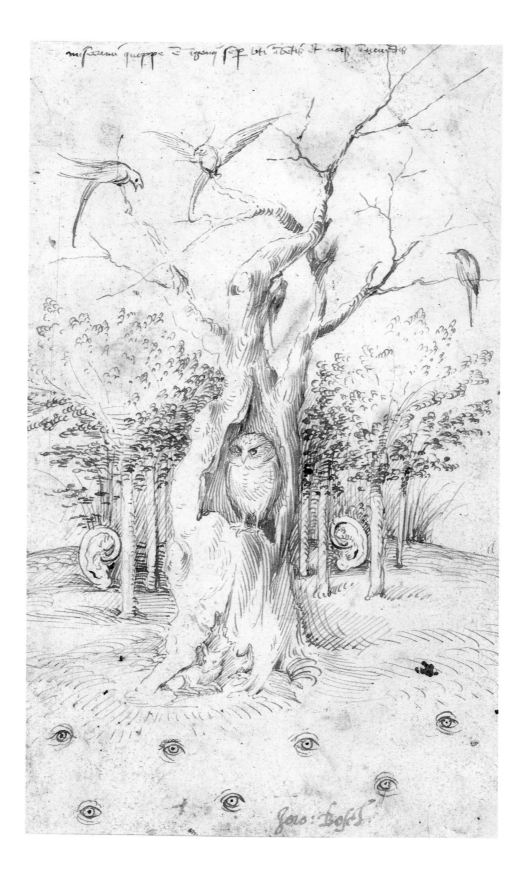

*The Forests Have Ears and the Fields
Have Eyes*
Pen and ink drawing
Kupferstichkabinett, Staatliche
Museen zu Berlin, Preußischer
Kulturbesitz, Berlin

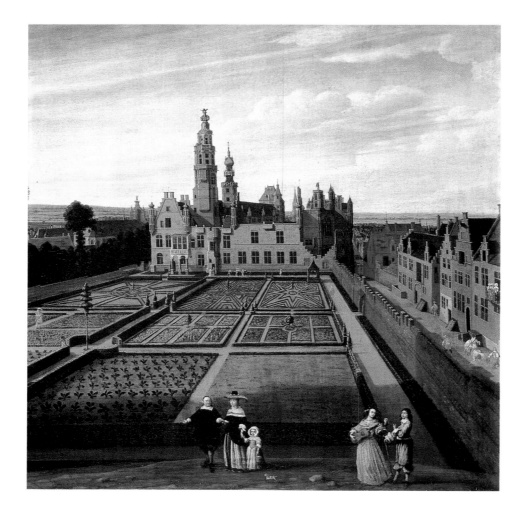

Wilhelm van Schoor
Palais Oranien-Nassau in Brussels (detail), 1654
Museé Royaux des Beaux Arts de Belgique,
Brussels

The *Garden of Earthly Delights* is documented as being in the town palace of the Counts of Nassau in Brussels just one year after Bosch's death, though this fact only came to light in 1967. The work could hardly have been displayed in a more prominent place in the courtly circles of the Netherlands, with the possible exception of the neighbouring Hapsburg residence on Coudenberg. The palace was frequented by the crowned heads of Europe and cultivated visitors, including Dürer, would call here to admire the architecture and to see Bosch's painting. The triptych therefore cannot be interpreted solely as a flight of the artist's imagination. After all, the buyer had also taken a risk. Such an unconventional work could only have been negotiated in close cooperation with a congenial patron of considerable confidence.

That description would certainly fit both Engelbrecht II of Nassau and his nephew Hendrik II (1483–1538), who inherited the estate of the House of Nassau on Engelbrecht's death in 1504. There is much to indicate that Hendrik was in fact the patron who commissioned the work. Engelbrecht had been a close friend of the Burgundian Archduke Philip the Fair, who had appointed him Stadholder General of the Netherlands. Hendrik, however, was closer in age to Philip and, even before 1504, accompanied him on all his journeys. Philip's untimely death in 1506 at first curtailed Hendrik's influence in courtly circles. Philip's father, the Emperor Maximilian, appointed his recently widowed daughter Margarete as Regent. At her court in Mechlin, Hendrik had to prove himself by showing his military prowess. Nevertheless, Hendrik remained a protégé of Maximilian and was twice received at the Emperor's residence in Breda. In the education of young Charles, the future Emperor, he even seems to have gained greater favour than Margarete. Charles is said to have "loved him very dearly" and, on coming of age in 1515, appointed his guardian Stadholder of Holland, Zealand and Friesland. By this time, Hendrik had profited from the rapprochement between the empire and France, which allowed him to marry into the House of Orange. In a letter written in July 1517, following his landing in Spain, Charles thanks Hendrik profusely for the loyalty he has always shown towards him.

illus. page 6 A portrait of Hendrik of Nassau painted around this time by Jan Gossaert shows an aristocrat in his mid-thirties whose bearing, though cool and aloof is not without a certain sensitivity. Around his neck he is wearing the ribbon of the Order of the Gold Fleece. His fashionable clothing is flamboyant in comparison with other portraits of this period. The very fact that Hendrik had his portrait painted by Jan Gossaert indicates that he had close personal connections with an aristocratic circle of collectors who favoured the works of the

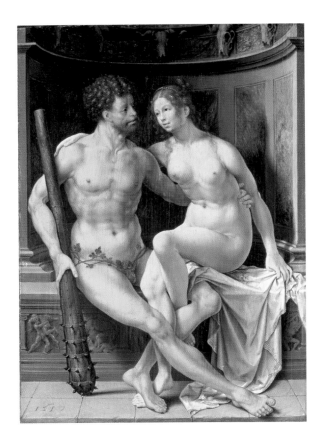

Jan Gossaert, *Hercules and Deianira*,
c. 1517, The Barber Institute of Fine Arts,
University of Birmingham/Bridgeman
Art Library, Birmingham

Italian Renaissance. Gossaert was court painter to Philip of Burgundy, last surviving scion of the ancient Burgundian dynasty of the pre-Hapsburg age and the only member of the ruling house with a humanist background. Gossaert had accompanied his patron on a journey to Rome in 1508 and had gathered lasting impressions there. At Souburg Palace in Zealand he was one of a team of artists employed to transform Philip's residence into a magnificent Renaissance court.

Hendrik purchased from Gossaert a painting depicting the myth of Hercules and Deianira, which, like Bosch's triptych is documented as being in his possession in 1517 *(above)*. A small painting of the same subject at the Barber Institute of Fine Arts in Birmingham gives us some impression of how it may have looked, though this was not the version owned by Hendrik. This tale of marital woe, culminating in Hercules being poisoned by his jealous wife, may merely have been used as a vehicle to create an erotic portrayal of two nudes, just as Gossaert had treated other classical themes. Gossaert elegantly appealed to his clients' knowledge of classical mythology. There was no tradition of painting such subjects. Their place was in an early art collection in which there were no qualms about the portrayal of ancient gods and where fiction was accepted as the privilege of painting.

In 1531, a Venetian diplomat drew a character sketch of Hendrik when he wrote: "No-one enjoys the favour and esteem of the Emperor (Charles) more than the Count of Nassau. He would have even greater influence if he would take on the burden of state affairs and seek to apply his power, for the Emperor dearly loves him. Yet he shies away from the labours of state business and attends only those meetings of the state council that the Emperor himself attends. Then he speaks his opinion freely." His life was geared more towards pleasure and enjoyment, and this is also reflected in his sense of humour. For example, his comment on a marriage portrait he was sending to his German relatives was that his wife wished "she were prettier ... and that I were a little younger."

Antonio de Beatis, who visited the Netherlands in 1517, describes the Palais Nassau in Brussels, mentioning not only the many views through trompe l'œil doors, but also a huge bed that Hendrik had commissioned because "he often held banquets and enjoyed seeing his guests drunk. If they had drunk so much wine that they could no longer stand, he would have them thrown onto the said bed." Not surprisingly, Hendrik had little interest in questions of faith and warned his brother in Germany against Luther's teachings with the argument that there should not be "two faiths in one house." What he lacked in piety, he certainly made up for in artistic interest and this must be taken into account in interpreting Bosch's painting.

Hendrik had his Breda residence transformed into a Renaissance palace by an Italian artist and had a magnificent Renaissance tomb created in the Grote Kerk for his uncle Engelbrecht. When the Elector of Saxony sent him a picture of Lucretia by Lucas Cranach in 1520, Hendrik thanked him, noting that, if his patron were patient, Cranach "would yet prove to be a master." According to Karel van Mander, the 'Dutch Vasari,' both Jan van Scorel and his colleague B. van Orley created a number of paintings for the Breda residence. De Beatis reports that, in the Brussels palais, he saw "many beautiful paintings including the tale of the Judgment of Paris with the three goddesses," familiar to us from Cranach's oeuvre.

Renaissance painting, with its taste for classical subjects, which arrived in the Netherlands around 1515 and soon caught Hendrik's imagination, belongs to a new era. Yet Bosch's *Garden of Earthly Delights* had also been to his taste. We do not know when the work was painted or when he bought it, but it would appear to have been in his possession for some time when it was first documented in 1517. The chronology of Bosch's œuvre sheds little light on the matter, whatever scholars may claim. Studies of the felling dates of the trees from which the wooden panels were cut (dendrochronology) are of little help either, for in our case they merely allow us to assume that Bosch used old, seasoned wood from the period around 1460–66. For this reason, another way

of determining the circumstances under which this work was commissioned has to be sought. One important clue is provided by a document, dated 1504, in the city archives of Lille, in which the artist known as Bosch is mentioned for the first time.

In September of that year, Philip the Fair, who, like Hendrik, was staying in Bosch's home town, paid the artist the sum of thirty-six pounds as an advance "for a large picture nine feet high and eleven feet wide." Philip stipulated that the picture should show "The Judgment of the Lord, which is to say Paradise and Hell" and that it should be "pour son très noble plaisir" (for his most noble taste). The wording may signify a topos, but the text unequivocally states that the Archduke wished to satisfy his personal aesthetic ideas by a private purchase. The work is not extant and, given the untimely death of the patron, it is possible that it was never delivered. We may assume that it was similar to the Last Judgment altarpiece in the Akademie der Künste in Vienna. The very fact that the subject matter is not, in itself, unusual, makes the central panel all the more remarkable. The actual Judgment scene is reduced to a marginal note in the composition, while the diabolically degenerate world that spreads across the main stage, ignores the heavenly justice, having already passed sentence on itself.

Even though it was intended for private use, the painting commissioned by Philip was considerably larger than the Vienna painting. If the format determined by Jan Mosmanns (2.56 x 3.16 m) is in fact correct, that would make it larger than any other known work by Bosch, including his largest surviving work, the *Garden of Earthly Delights*. In other words, Philip offered Bosch a spectacular opportunity for putting his extravagant visual imagination to the test. In this light, we must ask whether it is a coincidence that the inner wing panels of the *Garden of Earthly Delights* so clearly reiterate the scheme of a Last Judgment altarpiece (Paradise and Hell) without actually presenting the Last Judgment and, indeed, without even being an altarpiece. The crux here is the lost reference to a Last Judgment whose central scene has been substituted. The Last Jugment was an ambitious project, but it was surpassed by the *Garden of Earthly Delights* with its unprecedented subject matter. The theme was addressed to those in the know, to whom the enigmatic contrast with the Last Judgment would have been immediately obvious. The Paradise we are shown here is not the heavenly Paradise where the good are welcomed at the end of their days, but offers an innocent view of an earthly Paradise from which man and woman were never expelled and so they need not be judged (p. 87). It is tempting to imagine the two friends, Philip and Hendrik, indulging in an aristocratic game of artistic one-upmanship in commissioning their works of art. Hendrik, who had inherited the vast fortune of the House of Nassau in 1504, raised the stakes with a theme that was sure to attract the attention of the

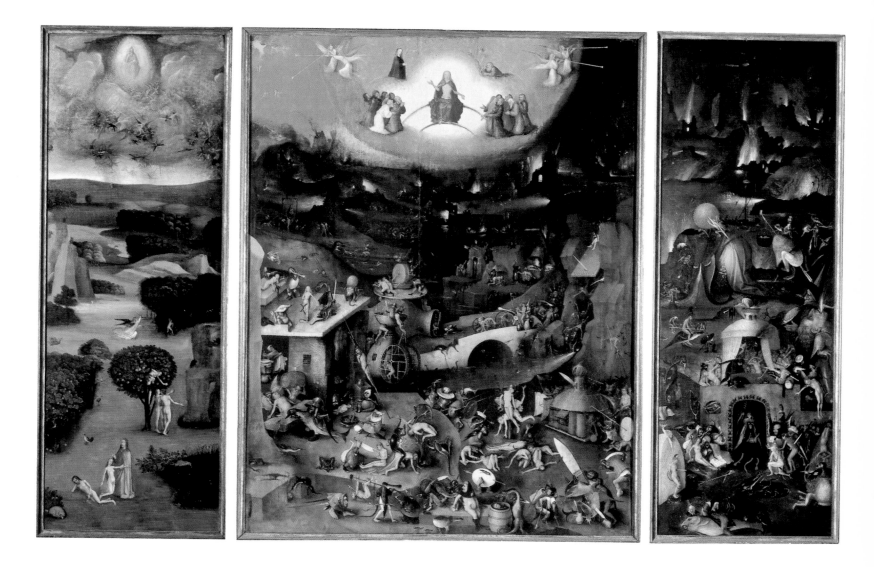

Inquisition. A connection between the two works seems all the more plausible if they are regarded not simply in terms of the uncertain chronology of Bosch's œuvre but as the nascence of a remarkable artistic concept.

There is no surviving document that gives any hint as to how the work was received at the time. Not even Antonio de Beatis, who wrote the travel diary of the Spanish Cardinal Luis of Aragon in Apulian dialect, provides more than a few superficial comments that indicate how little he knew of the Netherlands. The Nassau residence, which he describes as "very expansive and beautiful in the German (Gothic) style," captivated him by its magnificence and its wealth of nude paintings. Accordingly, he reacted with naive pleasure to the 'bizarre things' in Bosch's painting, in which he saw landscapes "and much more besides, how [people] crawling from a seashell ... women and men, white and black, in various positions and acts, birds, all manner of creatures, and very

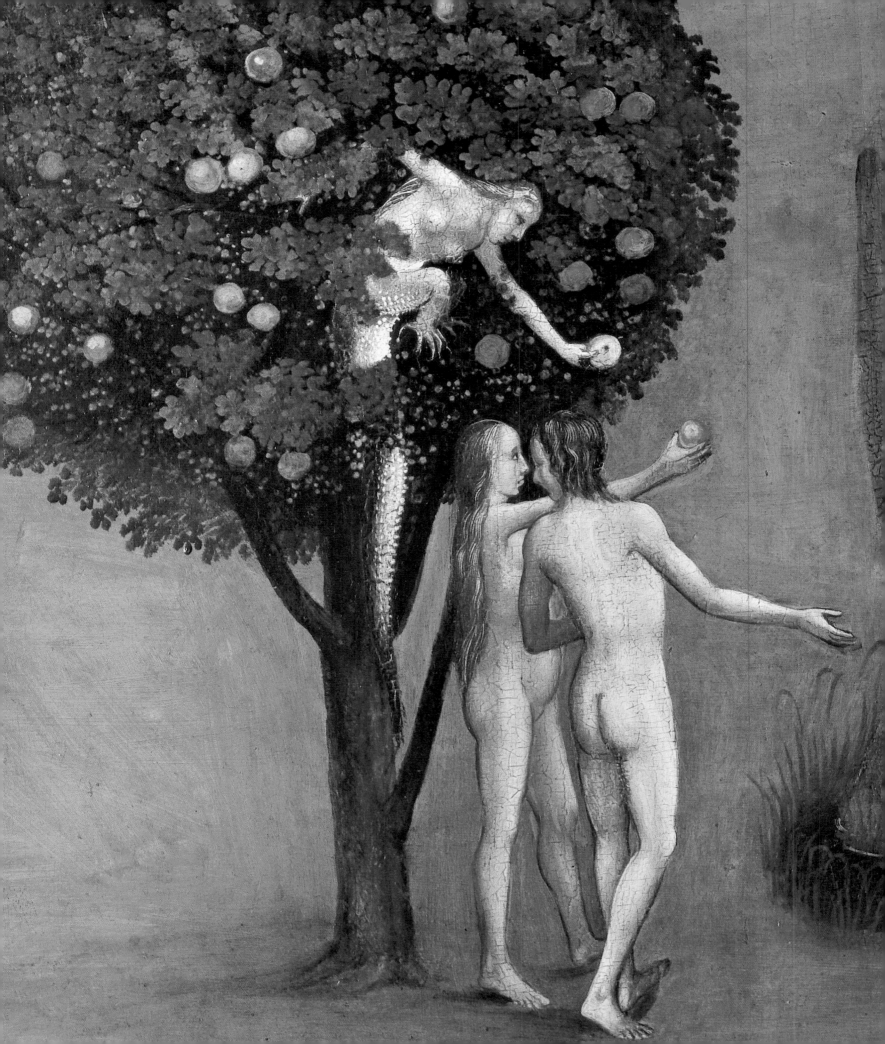

true to nature, things so delightful and fantastic to see that it is impossible to describe them to those who do not know them." Clearly, the work was not explained to him on his visit to the palace or, if it was, he had quickly forgotten. However, he was right in one respect: it was not possible to describe this unparalleled painting to someone who has never seen it.

Albrecht Dürer was a very different matter indeed. He would have been the perfect interpreter when he arrived in Brussels three years later, in the summer of 1520, on his tour of the Netherlands. But he does not mention Bosch's painting at all. As it is documented as being in the Nassau Palais until the second half of the sixteenth century, he must have seen it, unless, as is highly unlikely, it was not accessible for viewing on the day of his visit. However, there is method in his silence, for it expresses his disapproval. Dürer admired the old masters such as Jan van Eyck and even paid an admission fee to see a painting of St Luke by Rogier. Bosch must have confused him, with a lack of classical proportion so far removed from his own aesthetics. In his book on proportion, Dürer claims that "no good picture can be made" without the concept of a good scale and that one should "remove nothing from nature and impose nothing unbearable on it." Nevertheless, Dürer's report of the palace provides a welcome complement to the report by De Beatis. In the palace chapel, he saw "the good picture (*gemähl*) made by Master Hugo [van der Goes]." In other words, the palace possessed an altarpiece by this great artist, which must have come into the possession of the House of Nassau in Engelbrecht's lifetime. "And I saw the two lovely large rooms and all the sumptuousness of the house, including the large bed where fifty people could lie. And I also saw the large stone that was cast down by the elements next to the Lord of Nassau in a field. This house is set high (on the Coudenberg above the city). From there one has the loveliest view, which is quite astonishing. And I do not believe that it has its like in all the German lands." The mention of the meteorite confirms the impression that an early collection of artistic and natural *mirabilia* was being built up here, in which Bosch's work also had a place in terms of content. The tourist legend claiming that the stone fell from heaven right beside Hendrik legitimises the Count as the owner of the meteorite.

In this setting, Bosch's triptych was not an altarpiece, though the form of the work might suggest this. It was to be found in a collection that foreshadowed the later *wunderkammer* collections of art, artefacts and minerals. Nor do the biblical subjects of the picture retain their primary meaning here. Instead, they bear witness to a history of the world with fictional or pessimistic traits (p. 89). As a wonder of art the work broke entirely new ground. Its impact in the palace can only be surmised. Let us imagine that the host has held one of his many banquets. After the first glass of wine, he leads his guests to the work, which is closed. Although they have heard many wonderful things

about it, they are disappointed at the sombre, empty exterior which is not even coloured. Seeing their faces, the count instructs a servant to open these huge, gloomy doors. When the wings open, there is a cry of surprise from the assembled party. In an explosion of colour, the *Garden of Earthly Delights* appears as a sensation – something never seen before in painting. Hendrik enjoys the astonishment of his guests and laughingly calms their fears that they have enjoyed a view of something forbidden by the church.

Of course, this scene is entirely fictitious. Yet Bosch's work was surely destined for just such a form of presentation if its format as an altarpiece was to make any sense. The liturgical custom of opening up the church altarpieces for the faithful to see on high days and holy days cannot have been intended here, and, given the subject matter, would have verged on parody. In a social context, it must surely have been intended for a theatrical presentation in which the triptych would appear as a *wunderding* (marvel), to quote the term used by Dürer to describe the trophies from the New World in the adjacent residence of the House of Burgundy. The exotic plants and foreign races painted by Bosch pandered to a yearning for distant places that was still easy to satisfy, given the dearth of reliable information from the new colonies. Art of the kind represented by Bosch's *Garden of Earthly Delights*, heralding the future of collecting, had not yet developed its own concept. Art was still linked with the notion of virtuoso craftsmanship. It was the advent of mythological themes and references to antiquity, soon to become established in painting, that paved the way for a notion of art based on aesthetics.

The Nassau collections were scattered throughout a number of places, though the castle of Breda appears to have been the focal point. Some of the collection was later brought to Spain following Hendrik's third marriage, in 1524, to Menzia de Mendoza. The remainder of the collection was confiscated by the Duke of Alba in 1568. There were probably also exotic objects and natural wonders in the collection. Hendrik's curiosity about the discoveries being made overseas is evident in a letter he sent from Spain to his brother Wilhelm in 1522. In it, he reports the discovery of "a new island and province," of which it is said that it is "quite as large as all of Europe. And the first city they found there is called Tenostitan Mexico, in which there was much gold and sixty thousand houses." Hendrik also built up a library, as befits a cultivated house.

We know rather more about the collections held by Margaret of Austria during her reign (1506–15 and 1518–30). After she was widowed, she extended her residence in Mechlin. A rival of Hendrik, she was just three years his senior, but her interests were very different indeed, as indicated by the large number of religious pictures in her state bedchamber. As regent, she received many precious gifts, including ethnographic objects from the New World, yet she also

gave away many items in the interests of diplomacy. Religious images and portraits representing dynastic mores formed the basis of a collection that had yet to take on a clear outline in Hendrik's day. The painstaking care with which the regent Margareth compiled and documented her collection could hardly be expected of Hendrik, who led such a very different life.

The Hotel de Nassau was destroyed by fire in 1701. What remained was incorporated into library and museum buildings in modern times. An all too brief description by Roest van Limburg, in 1907, charts the history of this town house built between the 1480s and 1520s. It includes photographs of the Late Gothic chapel dedicated to St George, installed by Hendrik. A 1654 painting by Wilhelm van Schoor gives an impression of how the complex looked in the seventeenth century. Beyond the newly landscaped garden, the large town house with tower still retains its Gothic appearance. The elevated situation on the Coudenberg, high above the rooftops of the city, explains the enthusiasm with which Dürer described the unique view. Alongside the Gothic houses of the surrounding area, the palace has the air of a regal residence.

Bosch's triptych, displayed in a palace already regarded as a sight of interest in Brussels, surely enhanced his reputation as an artist, which rapidly spread throughout Europe. The fame of this painting is evident in the fact that so many copies of it were made during the Nassau period before 1568 for high-ranking patrons who could afford an expensive replica. Most of the copies feature only the central panel, which is rendered faithfully. In an age in which written sources are few and far between, these replicas are an important indication of the high profile this work enjoyed even a generation later. Exhibitions mounted by the Prado and the Museum Boijmans in Rotterdam recently included three of these early copies. Among them is an outstanding copy from a Brussels collection. It is of such high quality that it has been attributed to Michiel Coxcie, who also copied the Ghent altarpiece for Philip II. Another outstanding copy is the one in the Germanisches Nationalmuseum in Nuremberg, which reproduces the original with astonishing attention to detail, albeit in more subdued and warmer colours. Understandably, there were also a great many counterfeits at the time (p. 61). One generation after his death, a veritable 'Bosch renaissance' blossomed in complete contrast to the Renaissance fashion of the Netherlandish Italianists.

Among these many copies, most of which were painted a generation later and on a considerably smaller scale, there is one major exception. Only the left-hand panel, with the depiction of paradise and half the earth, has survived, and is now in the Prado in Madrid. It is an exception in that it reiterated the entire work in more or less the format of the original (188 x 77 cm). The felling date (1449–55) of the wood on which it is painted is even older than that of the original, indicating that it was very probably created during Bosch's

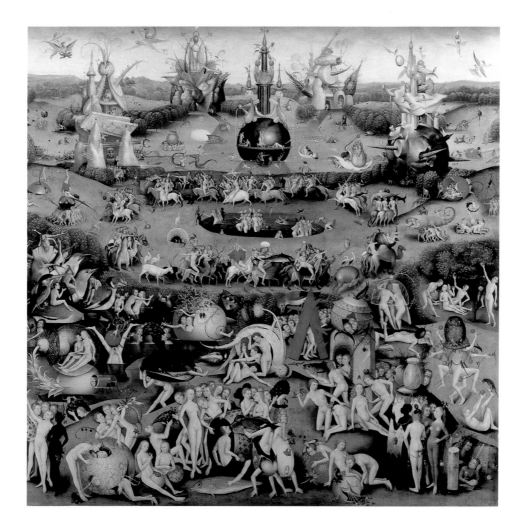

own lifetime. Unfortunately, it has been so heavily overpainted that little can be said about the painterly technique. Nevertheless, it is tempting to imagine that someone in the close circle of the Count of Nassau, perhaps even the Archduke himself, had ordered a replica of the work to be made in Bosch's workshop.

Later copies of the *Garden of Earthly Delights* also took the form of wall tapestries. Tapestry had become an established medium for the reproduction of famous paintings, and tapestries, like paintings, were hung in princely residences. A cycle of wall tapestries 'after the design of Hieronymus' (*des devys de Hieronyme*) is first mentioned in an inventory of the royal household drawn up on behalf of Francois I in Paris in 1542. In it, we find references to the same motifs that were also chosen in the series dating from the 1560s: *The Temptation of St Anthony*, the *Haywain* and *Garden of Earthly Delights*. The inventory provides the earliest iconographical description of *Garden of Earthly Delights*, specifying that it presents "the world, Hell, and earthly Paradise (le paradis terrestre)." Either the central panel has been omitted as unidentifiable or else

Copies based on
Garden of Earthly Delights

Copy of the central panel, before 1568
Private collection

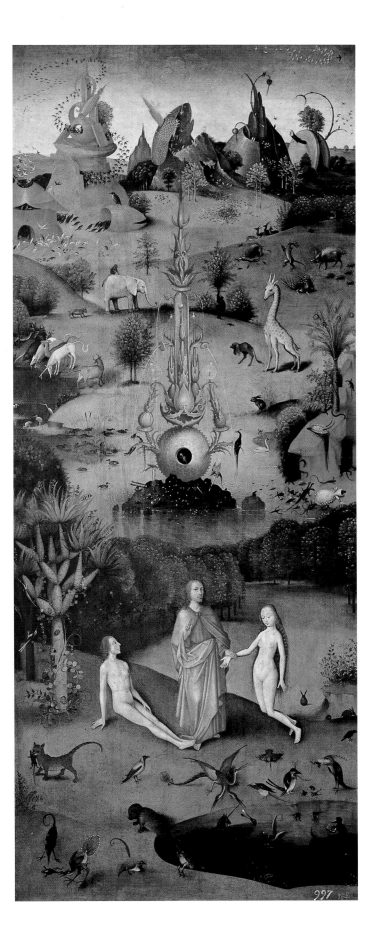

The left-hand wing of the only copy
made during Bosch's lifetime still extant.
Museo Nacional del Prado, Madrid

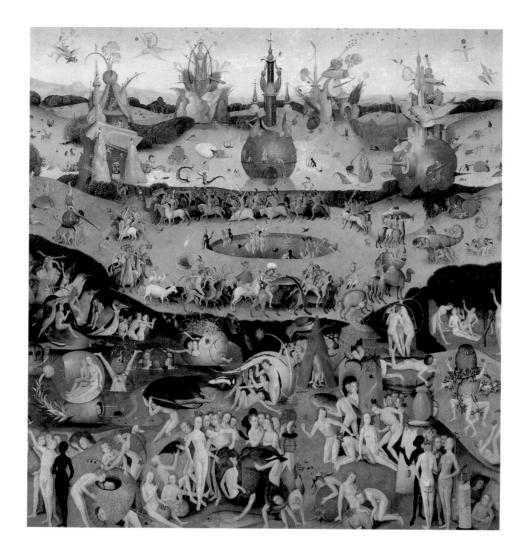

Copy of the central panel, *c.* 1540
Germanisches Nationalmuseum,
Nuremberg

it is precisely this that is described as 'le paradis terrestre' – which, in my opinion, would be absolutely correct.

Like any other tapestry of the time, the Paris cycle of tapestries produced in Brussels or Antwerp must have been based on a cartoon (*patron*). The cartoon would have been drawn up in the 1530s and several copies would have been available. This would explain how a new set of tapestries came to be produced in the 1560s. O. Kurz has reported in detail on this. In June 1566, Antoine Perrenot de Grandvelle, who had been living in the former Mechlin residence of Margaret of Austria since 1560 as cardinal, was informed by his agent in Brussels that 'the new Bosch tapestries' were ready for dispatch.

At the time, the Spanish reign of terror had begun. The Duke of Alba had disempowered the cardinal, forced the Hapsburg regent to abdicate and driven William of Orange, the Nassau heir, into exile as a rebel.

Alba soon wanted a similar cycle of tapestries for himself, and in October 1567 he asked the cardinal to lend his in order to have them copied. The

cardinal's factor suspected a trick and delayed the handover. In the end, however, he had to give in, and in December, he reported that Alba had received 'the large Bosch tapestry' that he had requested. It must have been the one showing the *Garden of Earthly Delights*. A tapestry cycle of this kind, which is not documented in Spain until the reign of Philip IV, has survived in the Spanish crown collections, the Patrimonio Nacional. The tapestries are almost three metres high and set the Bosch themes, like panel paintings, in architectonic frames. The *Haywain*, on a globe before an ocean, is shown in mirror image, indicating the use of an interim sketch between the painting and the cartoon. The same is true of the *Garden of Earthly Delights*, in which all three scenes are reproduced in mirror image. Since the tapestry retains the tripartite form of the original, it is considerably wider than the other carpets. The three wings in subdued colours are divided by columns. There must have been a special appeal in finding the famous original in a textile version, in which Bosch's painting is transposed from its carrier in such a way that it could no longer be specifically determined in terms of its medium.

The Duke of Alba wanted such a tapestry to be copied so that the tiny figures could be 'made still larger' (*Fait fere les personnaiges plus grant*), as the factor informed the cardinal. In order to prevent the transaction, the factor had told Alba that "the original was in the possession of the Prince of Orange, and would be better suited to making a cartoon for the tapestry" (*que le principal est*

sur le prince d'Orange sur lequel le patron se peult mieulx Faire). The letter was written on 5 October 1567. Three days later, Alba ordered the confiscation of all the possessions of William of Orange, the heir to Nassau after Hendrik's son. In doing so, Alba aimed to weaken the rebel he regarded as his arch enemy, along with Egmont. He grasped the opportunity of quickly taking possession of the original painting by Bosch, having previously sought to acquire a tapestry copy. The inventory of confiscated property drawn up on 20 January 1568 lists 'a large panel painting (*tableau*) by Jeronimus Bosch' which must be none other than the *Garden of Earthly Delights*. The new owner, Alba, later left the painting to his natural son, Prior D. Fernando. This explains how, two years after the latter's death, in 1593, it was purchased from his estate for the Escorial. This marked the beginning of its new career as the property of the Spanish state, as mentioned above (p. 8).

Within Bosch's œuvre, the large triptychs constitute a genre in their own right, whereby a distinction can be made between the true triptychs and those that are merely paintings with several wing panels. Triptychs, properly speaking, are works that present three different themes on the three inner panels, and link them together, whereas the triptych of St Anthony in Lisbon, to name but one example, relates the same legend three times and places it in the same setting. True triptychs are sometimes referred to by art historians as 'world triptychs' because they address the history and collective fate of humankind in the world. The Last Judgment displays the traditional form of such a triptych, the archetype as it were, though the Vienna version can hardly be said to treat the subject in a traditional manner. The wing panels present the two places to which the redeeemed and the sinners were allocated, respectively. Yet in the case of the Vienna triptych, even the portrayal of the Last Judgment undermines the familiar scheme. The Paradise panel, for example, does not show the future Paradise to which the blessed can aspire, but the former Paradise from which the first man and the first woman were expelled after the Original Sin. Thus, a linear history is introduced which secretly reverses the post-historic message of the Last Judgment's apocalyptic panorama. The Fall of Man is the start of a sequence that ends in Hell.

illus. page 75

illus. page 86

The so-called *Haywain*, of which several versions exist, and of which the version in the Prado is not necessarily the original, adopts the compositional scheme of the Last Judgment altarpiece in presenting Paradise as the prologue and Hell as the epilogue. Yet here, too, the linear narrative is underpinned by the composition: in the Paradise panel, the Expulsion points the way, and directs the spectator's gaze, towards the continuation of history in the following picture. The direction of the narrative is intensified in the Hell panel where the head of the procession, having crossed the central panel, reaches its destination. But what kind of a procession is it? In the manner of a solemn procession, a haywain is being driven along with neither rhyme nor reason, accompanied by all manner of secular and religious authorities, its humble load revered as though it were gold, until it finally ends up in Hell with its foolish followers. *The Haywain* is a verbal metaphor translated into visual terms. It calls for an allegorical reading that goes beyond first impressions. In this respect, it combines the verbal and the iconic in a way that opens up a whole new dimension in art. The foolishness of the world is summed up in this triptych. The outer panels amplify the effect by portraying a vagabond erring through the world, for which the same colours are

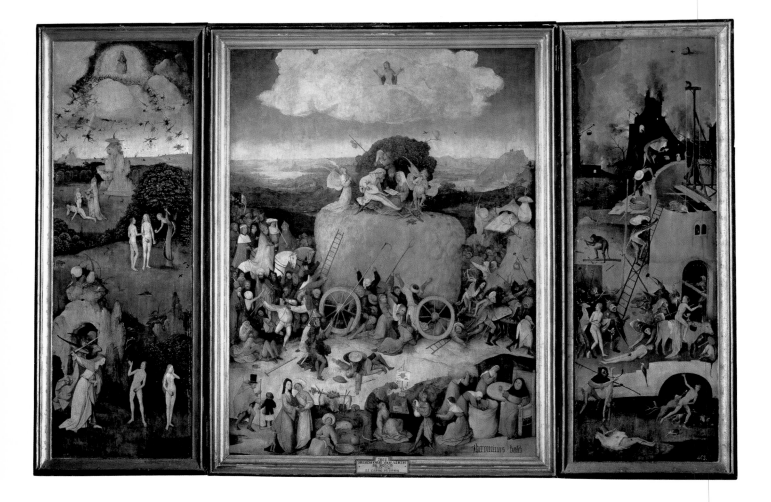

The Haywain, 1485–90,
Museo Nacional del Prado,
Madrid

used as for the interior. In Bosch's work, the vagabond represents humankind as a guest in this world, who is merely passing through.

Garden of Earthly Delights presents another way of using the age-old scheme of the Last Judgment as a vehicle for new subjects that did not yet have their own visual form. This is not necessarily to be thought of as a chronological sequence, with the *Haywain* as a forerunner. Instead, the idea for the *Garden of Earthly Delights* would appear to have been the product of the rivalry between Philip the Fair and Hendrik of Nassau (p. 74). The prologue and the epilogue of the *Last Judgment* are reiterated in the *Garden of Earthly Delights*, but this time, in the Paradise panel on the left, no-one actually eats of the forbidden fruit. This means that the sub-text which drives the linear narrative of world history in the other two triptychs does not come into play. Here, the triptych offers a very unusual narrative of the world, introducing the story on the outside with a view of the unpopulated earth. The visible continuity between the Paradise in which only Adam and Eva lived, and the overcrowded Paradise, of the central panel stands in such stark contrast to the biblical version that it demands to be read in a completely different way. The question is how?

This brings us to the question that has been the focus of all interpretations of the painting and which has always been a bone of contention among scholars. Anyone who knew the bible had to admit, even then, that this innocent state of Paradise not only never existed in the biblical text but goes entirely against the grain of biblical logic. But could Bosch risk abandoning the realms of biblical truth once he had taken up a biblical subject? And could he have expected his patron to display a false or arbitrary interpretation of the bible so publicly under the ever watchful eye of the Inquisition? The answer to both questions must be no, he could not. But what if there was a gap in the Bible, a gap between what might have happened and what actually happened? What if the Bible itself allowed room for a figment of the imagination, room to muse on how life in Paradise might have been without the Original Sin? Bosch is so utterly faithful to the biblical text in his other images that we must surely assume that the central panel is also based on a biblical background that can be quoted. Such texts can indeed be found in the Bible. However, before Bosch, no painter had dared to take inspiration from them, and for good reason. After all, it went against the basic rule of thumb by which biblical iconography could only narrate what had actually happened or what would happen in the future according to Revelations. Not only did Bosch take up an original biblical paraphrase, but surely also knew that in doing so he was calling into question the significance of religious painting. This thesis demands a closer look at the biblical text. When he made the first man and the first woman, God had completed his Creation. The third chapter of the Book of Genesis opens with the most portentous quantifier – *sed* (but) – in all of literature: "But the serpent was more subtil than any beast of the field which the Lord God had made" (Genesis, 3:1). Satan tempted man to fall from grace and, in doing so, sabotaged God's plan. By omitting the Fall of Man, Bosch fills out a gap in Creation in which there is a place for all things – an ideal that remained an unattainable utopia after the Fall. Astonishingly, there was no need for Bosch to dream up this utopian vision by himself. Once again, he merely had to consult the Bible. In the second chapter of the Book of Genesis, the intended Paradise is clearly described.

In the Latin text of the Vulgate, approved by the church, God created a *paradisum voluptatis*, or 'paradise of lust.' This was the version Bosch knew, for he could not possibly have known the Lutheran or other modern translations that kept closer to the rather more bland Hebrew phrase of a "garden planted by God eastwards of Eden." This mention of a paradise of lust has long posed a problem to theologians, for it is still offensive even in view of the Creator's call for mankind to "Be fruitful and multiply, and replenish the earth" (Genesis 1:28). But the word of the Bible is sacred. Augustine tried rather uncomfortably to claim that reproduction in Paradise had been a matter of necessity

rather than lust (City of God Against the Pagans, Book 14:23). Medieval theologists comforted themselves with the thought that, in Paradise, human fertility had been a natural trait void of all eroticism. Chastity would have made no sense in a place that knew no sin. In this respect, the very name of Paradise was a provocation.

Bosch was also able to make use of the enigmatic description of Paradise in chapter two of the Book of Genesis, which describes a river going out of the "place of lust" and dividing into four to water the garden. Bosch took this description literally by portraying the lust mentioned in the name and showing the couples on and in the blue sphere in frivolous situations (p. 47). He also kept close to the Bible in showing this 'place of lust' as the centre from which the river springs. The Bible provides both an image of a spring and an image of the "tree of life also in the midst of the garden" (Genesis 2:9). The hybrid that Bosch creates is neither spring nor tree and yet it is both, whereby the two figures of speech merge in a fantastic entity. Bosch saw the transformation of the elements in Paradise as a natural drive, unlike the transformation of the alchemist's laboratory, and this explains why he was able to turn the veined pod so easily into a blue globe. The four rivers also correspond remarkably precisely to the biblical description. The first river "compasseth the whole land of Havilah, where there is gold;/And the gold of that land is good: there is bdellium and the onyx stone." The second river led to "the land of Ethiopia," from where the dark-skinned people came who are among the whites in the foreground. The third river "goeth toward the east of Assyria. And the fourth river is Euphrates" (Genesis 2: 11–14). This description situates Paradise firmly within the geography of the world, in which exotic realms are indicated by a crescent moon, while the description of precious stones echoes the fairy-tale description of a distant geology. The four strange portals that grace the four rivers are almost like exclamation marks, as though Bosch wished to confirm his knowledge of the biblical geography of Paradise.

illus. page 49

illus. page 27

Other biblical authors fleshed out the meagre sketch contained in the Book of Genesis. Ezekiel describes Eden as the garden of delights (in deliciis) in which there are precious stones: "the sardius, topaz, and the diamond, the beryl, the onyx and the jasper" (Ezekiel 28:13). He reminds the iniquitous prince of Tyrus of the gold that was once his, "in the day that thou wast created," and that he had walked "in the midst of the stones of fire" (Ezekiel 28:13–14). This sumptuous image fuelled Bosch's imagination. But the *hortus voluptatis* mentioned by the prophet Joel had become "a desolate wilderness" after the Fall (Joel 2:3). The contrasts of oasis and wilderness are placed in a cosmic sequence. This course of things would be reversed, if, as Isaiah told the Jews in Babylonian captivity, repentance was done. Then they would return from the wilderness to the lost paradise (*delicias*): "... and he will make her

wilderness like Eden and her desert like the garden of the Lord ..." (... *et ponet desertum eius quasi delicias et solitudinem eius quasi hortum Domini* ...) (Isaiah 51:3)

Paradise promised yet never inhabited has often prompted attempts to go beyond the Bible and use imagination to fill the seeming gap. The notion of a golden age, prevalent in many cultures, is linked here with a paradise already long lost as a place before it could be populated at all. In the Middle Ages, the foremost issue was how people would have lived there before knowing sin. It was a question that was also addressed by Bosch's compatriot, Denys the Carthusian (1402–71), in his commentaries on the *Book of Sentences* by the great theologian Peter Lombard (*c.* 1100–60). According to Denys, paradise was large enough for the whole of humankind. People would live there in eternal youth. But for the clerics, who took vows of celibacy and wanted to keep their congregations under control, unfettered and unpunished sexuality was the most troublesome of concepts. They had to defuse the issue by maintaining that in such a paradise, lust was controlled by reason and moderation. Luther, a married man, had fewer problems with the same question. For example, in his *Colloquia Mensalia* (Table-Talk) he enthused about this imaginary paradise as a place where "all would have been like youths, frolicing naked and bare."

Bosch did not treat the subject of Paradise imagined in an ecclesiastical sense, but as an opportunity of portraying a utopian vision on a grand scale. He was not interested in illustrating the Bible, though a sound knowledge of the Bible was needed in order to be armed against those in search of heresy or likely to denounce any sign of it. While the patron who ordered the painting may have seen the subject matter as a form of social criticism, for Bosch this painted utopian vision was intended to give art the freedom that poetry had always enjoyed, allowing fiction to enter. In the case of the *Garden of Earthly Delights*, in particular, far too much has been said and written about the work, to the point of even branding Bosch a heretic without actually taking the artistic aspect into account. What kind of work is this that uses biblical motifs and yet goes beyond ecclesiastical-religious meaning with dream-like ease? For theologians, the secret scandal lay in the fact that Bosch replaced the divine judgment with a fictitious world that never existed. They had to be appeased by the fact that theology had passed the compositional baton on to art. Bosch sought an independent content for art which, in the meantime, he could only find in an idiosyncratic reinterpretation of conventional iconography. Freedom from the burden of earthly things was no longer a question of metaphysics, but a trophy of the imagination.

CARDINAL GRIMANI'S ALTARPIECE

This interpretation is fully vindicated when we look at another work by Bosch in which Paradise and Hell are portrayed in a way that conforms perfectly with the theological conventions of the church. The work in question consists of four panels in the Doge's Palace in Venice that were originally part of a larger ensemble – an altarpiece belonging, from 1521 onwards at the latest, to Cardinal Grimani. In it, Paradise and Hell once accompanied a depiction of the Last Judgment, prefacing it as places beyond earthly life. The contrast between the celestial Paradise shown on these panels and the exotic Paradise of the *Garden of Earthly Delights* in which a utopian society frolics could hardly be more marked. In the Venetian altarpiece, the blessed spend some time in the terrestrial Paradise that has been lost since the Fall of Man, before ascending to the celestial Paradise.

What we have here are the remnants of one of the most brilliant works from what is referred to as Bosch's mature period. The felling date of the wood is around 1484–90, to which some twenty years should be added. Reconstruction of the winged altarpiece which was broken up by collectors, is fraught with difficulty. The surviving panels (87 x 40 cm) have been cropped severely at the top and bottom, with the result that only half the fountain of the earthly Paradise remains in the picture. This indicates that the original panels were remarkably tall and narrow. But in what order were the double inner wings aligned? The panel showing the terrestrial Paradise seems to guide the gaze upwards towards the celestial Paradise, suggesting that it was originally mounted diagonally above in one of the upper zones. That leaves another four panels unaccounted for, whose subject matter can hardly be surmised. The remarks made by Marcanton Michiel, who visited the Grimani collection in 1521 do not really help us to solve the riddle – if he is even referring to the same work at all. He mentions only paintings on canvas by Bosch, showing Hell and 'Dreams' (*sogni*), which would certainly fit. Is it possible that, even then, the Cardinal had placed them in his collection as precious individual paintings whose original context was already lost? Although we do not know how the altarpiece originally looked, the surviving paintings do allow us to envisage the concept of the work as a whole.

The magical handling of light lends the panels a dramatic effect which is further enhanced by the enamel-like sheen of the brushwork, in stark contrast to the day-bright lighting in the *Garden of Earthly Delights*. The light lends added drama to cosmic spaces by illuminating the darkness, culminating in the tunnel of light leading to the celestial Paradise, which is present only as *illus. page* 95 absolute light radiating into the tunnel. The counterpoint to this is found in

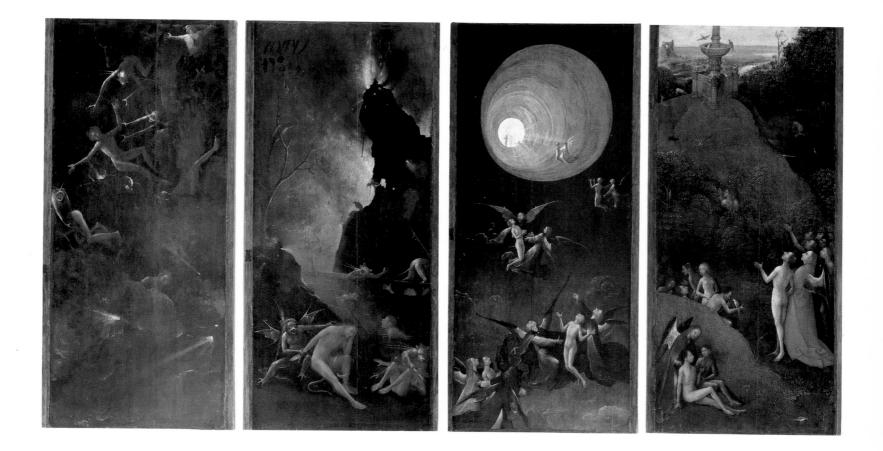

Wings of the Grimani Altarpiece
(Doges' Palace, Venice):
*The Fall of the Damned, Hell, The Ascent
of the Blessed into Celestial Paradise,
Earthly Paradise*

the fires of hell, with mountains and trees silhouetted before them. The garden panel of the terrestrial Paradise is predominantly green, the cloud panel blue and the twin panels of hell are brown. In Hell, which is a very different Hell from the one we see in the *Garden of Earthly Delights*, the damned tumble into a deep shaft, with the abyss ending in the rocky landscape of the next panel, lit by the glow of Hell's fires. Any memory of the world, so tangible in Bosch's other depictions of Hell, has faded here. The damned are abandoned in all eternity to the devices of their tormentors, in the form of bat-like devils. Some are drowning in a dark lake on whose shore a victim is having his throat cut. One of the damned bewails his fate in a silent gesture of melancholy.

On the two Hell panels, Bosch makes a distinction between the place of entry (the shaft) and the place of sojourn (the rocky landscape). The Paradise panels also distinguish between two places, albeit in a very different way. For the blessed, the terrestrial Paradise is like a waiting room, with the celestial Paradise out of sight beyond the clouds at the end of the tunnel in the second panel. Terrestrial Paradise, with the fountain of life on a hillock, is the place from which the first man and the first woman were expelled after the Original Sin. Now, in the company of angels, the blessed can re-enter this idyllic garden, where they rest on the grass and watch the birds. Some gaze longingly

91

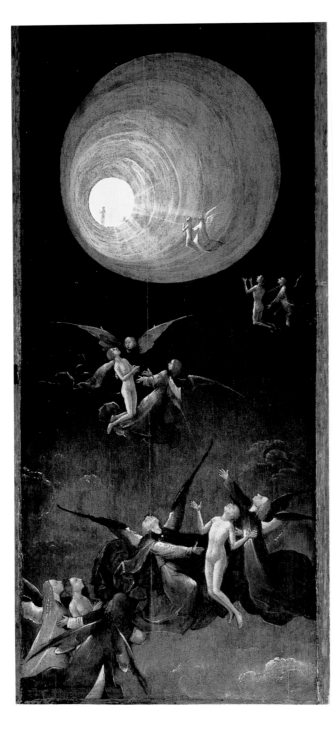

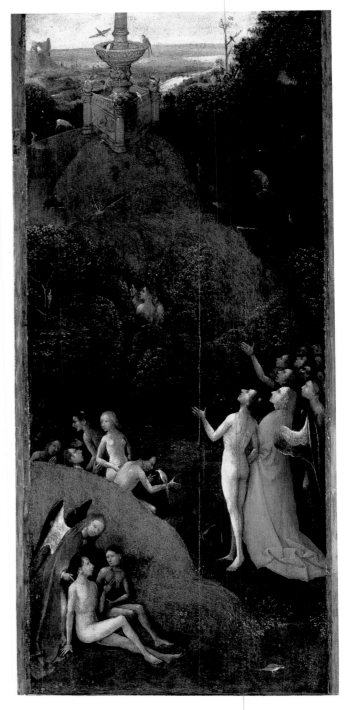

*The Ascent of the Blessed
into Celestial Paradise*

Earthly Paradise

upwards to the place where others are already ascending in the next panel. The theologist Denys the Carthusian taught that, after limbo, redeemed souls had to wait in terrestrial Paradise before being allowed to ascend to Heaven in accordance with the Last Judgment.

In the adjacent cloud picture, the celestial Paradise is, once more, portrayed only indirectly. Instead, we see the Ascent of the Blessed. The ascent begins between dark clouds, where each of the blessed is accompanied by two angels whose robes support them in their orant gesture. All of them have thrown their heads back as they look up towards their ultimate destination beyond the light. The blessed continue their ascent on their knees, accompanied only by one angel. They are drawn into the round shaft of blinding light with a body language of complete anticipation. In this, Bosch develops an idea Dieric Bouts had presented after 1468 in his *Last Judgment* altarpiece for the Louvain city hall (now in the Louvre). In Bouts' painting the blessed wait on a hill in Paradise to be carried away to heaven by angels through a parting in the cloud.

illus. page 95

Bosch heightens the drama of this underlying idea by replacing the parting in the clouds with a built shaft that leads out of the world into an open space. He

illus. page 94

may even have been inspired by the water tunnels of his home town, in which the light falling through a distant arch breaks against the rounded walls, as modern-day visitors can still see for themselves. The visual impression is handled with consummate mastery by the artist. He creates an architectural link between the visible world and the invisible celestial realms that conjures up a divine light reminiscent of the spiritual writings of the Flemish mystic Jan van Ruusbroec (1293–1381).

Art historians have often avoided analysing this work, because it does not quite fit the picture we have of Bosch as an artist. Even the painterly approach is not as we know it from other works. The terrestrial Paradise has nothing of Bosch's usual exoticism, appearing instead as an unsullied idyll in spite of the tiny background scene of animals fighting, reminding us that nature is red in tooth and claw. The garden as we see it could easily exist in reality. The fountain of life on the hillock is not a fantastically formed object as in his other works, but resembles a Renaissance fountain with four winged marble putti at its corners. The landscape that stretches out behind it seems almost too modern for Bosch's artistic ideas.

The dreams in which this artist portrays the hereafter in almost anecdotal terms are narrated in a way that is entirely tangible, drawing on religious iconography with enormous discipline and sensitivity, without ever slipping into the fantastic imagery we normally associate with Bosch. This sheds new light on the very different subject matter in the *Garden of Earthly Delights*, which Bosch circumscribes so freely that when we stand before it we find ourselves drawn into the labyrinth of his imagination, in search of some other,

Canal system in 's-Hertogenbosch

hidden meaning. The iconography of religious painting merely supplied the raw material for a fable containing both utopian traits (Paradise) and social criticism (Hell). It is not so much a question of going beyond the teachings of the church as one of creating a counter-image of the contemporary world, to which Bosch holds a mirror in the Hell panel of the same painting. The ambiguity with which he imbued his imagery was not just a means of self-protection, but also gave him the poetic licence to draw from the rich wellspring of his own imagination. A new concept of art – though yet to find a benchmark other than the technical skill of the older masters – was the key to a new visual understanding that has often been confused with hermetic content.

Cardinal Grimani's Altarpiece:
The Ascent of the Blessed (detail)

Dieric Bouts, Paradise wing of the
Last Judgment altarpiece, *Earthly Paradise
with the Ascent of the Blessed into
Celestial Paradise*, 1468–75 (detail)
Musée du Louvre, Paris

A NEW CONCEPT OF ART IN DIALOGUE
WITH LITERATURE

In Bosch's own world, art theory had yet to develop to the point at which such a project could have been interpreted and commented in appropriate terms. Yet, when it came to discussing the controversial issues of the day, writers and poets found themselves in a similar situation and they, too, chose ambiguity as a suitable means of expressing themselves. It has long been known that Bosch used common idioms and folk proverbs in his painting, but his position as an artist has not been examined in terms of the changes that were taking place in the field of literature at the time, as reflected in two works that treat a similar theme in very different ways.

One of the works in question is the *Ship of Fools* by Sebastian Brant, who bears a clear affinity with Bosch as a trenchant social satirist and moralist. The other is *In Praise of Folly* by the brilliant humanist Erasmus of Rotterdam, whose subtle fiction and poetic licence in the rendering of an imaginary Paradise can be compared with Bosch, as long as we bear in mind the problems such a comparison entails.

Both these works were published in Bosch's lifetime, within the space of less than twenty years, and yet separated by the watershed of an emerging literary concept. *Ship of Fools* (1494), of which Bosch's work is a pendant, if not a painted echo (p. 65), brands the foolishness of the world with a rugged immediacy that comes straight from the language of the ordinary folks. The fool, we are told: "Does not believe in Hell until he steps over its threshold himself." This satire of a world on the brink of Hell strikes a chord no less drastic than Bosch's portrayal of blindness and punishment. The utopian Paradise, on the other hand, is very different in spirit.

In Praise of Folly (1511) addresses the interior logic by embodying Folly in the form of a speaking allegory whose paeons of self-praise transpire as true wisdom. Folly is not a sin, but the ineluctable law of life. Only by seeing through and accepting one's own folly is it possible to avoid the imagined wisdom that is the worst kind of illusion. The author speaks with the voice of a person he presents as fictitious and thus has a freedom of speech no real person would dare to exercise. He refers to classical authors such as Lucian, defending his manner of speech on the basis of literary tradition (p. 109). The process of negation culminates in Erasmus' witty remark that it is a honourable thing to be admonished by folly. He wrote the work at the home of his friend Thomas More, who later responded with an analysis of a non-existent utopian society in his famous work *Utopia* (p. 107). In both cases, fiction liberates argument by disguising it.

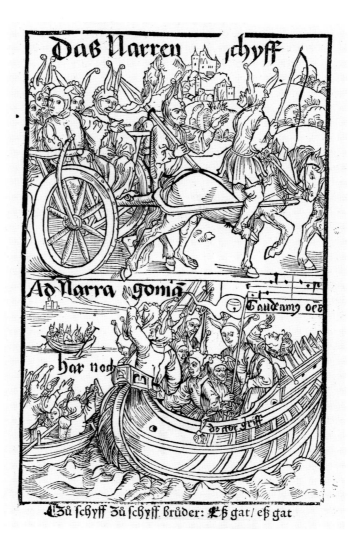

Sebastian Brant, *Ship of Fools*
woodcut

A comparison with Bosch's triptych may not necessarily spring to mind. And why should it, given that it is not painted literature, but a vision on a biblical basis? No matter how Bosch may have tried to mediate between the arts, the asymmetry between painting and literature set limits on the exchange between them. A member of the aristocracy, such as Hendrik of Nassau, did not belong to the same circles as the humanists. He would have had little inclination to struggle through long books in Latin. However, he would have been able to appreciate an enigmatic painting of intelligence and originality that made him the artist's accomplice when the guardians of the faith sought signs of heresy in the image. The unusual work also gave the owner a share in its creation. Having lost its religious function, it could only have a place in an art collection of a new type in which it took on a new significance as *mirabilia,* things to be marvelled at. Had Hendrik and the artist discussed the terms of the painting in the presence of a humanist, the following interpretation may

well have emerged. The central scene of Paradise revealed a 'no-time' beyond history (*Uchronia*), just as More presented a 'no-place' beyond the world (*Utopia*) (p. 107). History was a thing of earthly mortality with its beginning in the Expulsion from Paradise and its end in the Last Judgment. In Bosch's painted Paradise, time could never end, for it had never begun. Bosch's Hell panel confirmed this fiction in its own way by contradicting it and recalling the place where the sins of history were punished. Hell was a product of history.

The beauty of a perfect life of freedom could only be fictitious because it had 'no place' in sinful humanity. The very act of gazing at this painted innocence revealed to the spectator of the day the enormous discrepancy with his own reality that forced him to live with sin and punishment. The world in the picture and the world outside the picture were thus separate in a way that differed from the separateness that would apply to a religious view of the hereafter. Bosch could have chosen some other way of changing the conventional notion of painting as imaging and of expanding the leeway that art had. Being aware of the nascent interest in hieroglyphic visual syntax, he could have coded his painting according to a specific system in order to create a secret meaning using a pictorial alphabet of his own invention. Instead, he chose to give painting the kind of freedom that poetry and literature enjoyed in drawing upon mutable fantasy. While poetry was intended as a creation of obvious beauty, its content was couched in obscurity. It was one thing to enrich the visual vocabulary of painting, but another thing altogether to release it from the mimesis of the world and bind it instead to the creative imagination. This allowed the reproduction of reality to merge repeatedly with free invention in a syntax of beguiling ambiguity in which the border between reality and illusion was in a state of constant flux. Bosch's consummate skill in rendering the visible world lent credibility to the interaction between the imaged and the imagined. Art was yet to find its own identity, but with the arrival of Renaissance painting in the Netherlands, that identity was not where Bosch had sought it. This is why, after his death, all that remained of the art Bosch had developed single-handedly, was a fascinating memory.

The age of discovery was a source of both wonder and terror, for it meant the loss of the biblical Paradise as a real geographic place. The conquest and charting of the world irrevocably pushed the existence of a terrestrial Paradise into the realm of dreams. Paradise could not be turned into a colony without destroying it. Colonisation meant the disappearance of those imaginary places so long surmised in the unknown parts of the world. The realisation began to dawn that such places had existed only in the imagination. Imaginary space was devoured by empirical space. The notion of the biblical Paradise as a place on earth had to be abandoned. It had been a fictitious place of memory. The fiction consisted in recalling what one yearned for while denying its fictitiousness in the guise of a metaphor of collective loss suffered by humankind in the Expulsion from Paradise. Of course, the myth of Paradise was not

Lucas Vorsterman the Younger
Coudenberg Gardens in Brussels
copperplate engraving, 1659
In: A. Sanderus, *Chorographia Sacra Brabantiae,* The Hague, 1726

fictitious in itself; it was only through the departure from mythological think-ing that the fiction could be discovered in the myth. It was therefore only logical that, since Thomas More, new literary genres, openly working on the basis of fiction, had begun to replace the ancient tale of Paradise (p. 10). The new blossoming of utopian literature inherited the old mythological tradition represented by the Bible.

Bosch transposes the notion of Paradise from the collective knowledge of faith to the collective imagination of dreams. The fiction of Paradise gains its paradoxical charms from the authority of the Bible, which described Paradise. Yet, by fictionalising Paradise, Bosch undermines this biblical authority and places the subject matter firmly within the field of art. The presence of Bosch's triptych in the cosmopolitan city of Brussels provided the necessary resonance for a willingness to indulge in an imaginary world. It was a cosmopolitan set-ting for a rivalry of dreams. Dürer, who was familiar with Venice and who lived in the imperial city of Nuremberg, which was anything but provincial at the time, was utterly astonished at what he found in Brussels. In the ducal art collection he admired the trophies of the New World as though they were prizes from a recently discovered Paradise. Although Bosch's painted Paradise was also part of the topography of imaginary places to be found in Brussels, Dürer clearly did not identify with its artistic terms.

Etymologically, the ancient name of Paradise bears within it the memory of a garden in which animals lived in an idyllic enclave. The Greek word *paradeisos*, which entered the Old Testament in translation, is derived from the Persian word *parideza*, meaning an enclosed park in which the Persians indulged in hunting. The biblical Paradise was also presented as a utopian gar-den full of animals. The trees and plants were "pleasant to the sight and good for food" (Genesis 2:9). They were there for the birds and animals to eat so that they need not prey on one another. The exotic world, enriched daily by news and rumours from the New World, gave Bosch a licence to mix animals of his invention among the familiar fauna and flora (p. 57). In adding fictitious creatures to the animal world or portraying known songbirds as large-scale hybrids, he could be sure that his contemporaries would agree that nature in Paradise had been very different. Visitors to the Palais Nassau could reflect on which aspects of his picture were real, which were possible and which were freely invented. This painted nature also included the human being as a nat-ural creature that knew no cultivated civilisation and built no houses. Later, this nostalgic view would develop the formula of the 'noble savage.' In the work of Bosch, nature itself was a dream: the dream of Paradise.

Dürer thought little of such fiction, preferring to study the exotic animals that he was able to see for himself at first-hand in zoos. He analysed them as authen-tic natural creatures with painstaking attention to detail, drawing them from

Albrecht Dürer, *Rhinoceros*
woodcut, 1515
Germanisches Nationalmuseum,
Nuremberg

Albrecht Dürer, *Drawing of a Lion*
1520, Albertina, Vienna

life in Ghent and Brussels, as he noted in his diary. This does not mean that he produced 'portraits' of them. He drew them with photographic precision, thereby 'recording' them as aspects of nature for later inclusion in his repertoire. The walrus "caught in the Netherlandish sea," as he noted, was his most unusual trophy. Had he been able to see for himself the rhinoceros that he rendered in his famous woodcut of 1515, based on a drawing sent to him, the portrayal would have been more reliable. Dürer was a realist who made a distinction between nature and art: art could idealise nature, but should not fictionalise it.

The ducal Coudenberg park in Brussels, where he also saw exotic animals, fascinated him so much that, in the summer of 1520, he made a pen and ink drawing of the complex from the open window of the palace. He noted in his diary, "I have seen, behind the house of the king of Brussels, the fountain, labyrinth and zoo, and never saw more pleasant things that did delight me as a Paradise." A man-made Paradise, an enclave in the urban world, bordered directly on the residence that was the very centre of European politics, like an unspoiled counter-world, a dreamed-of natural idyll. The drawing bears Dürer's signature and a note in his own writing that this is "the zoo and pleasure garden in Brussels, seen from behind the palace." The idea of Paradise was a key element in the history of garden design, which explains why a recent exhibition on early gardens could be given the title 'Garden of Eden.' The palace gardens in Brussels were particularly beautiful and it is perfectly possible that Bosch's painted Paradise in the palace was actually intended to elicit a comparison with the Paradise beyond its walls.

The names *Garenne* and *Warande* recall the game enclosure that the former dukes of Burgundy had installed along the city walls of Brussels next to the

palace. By the time of Philip the Fair, the game enclosure had already become a zoological garden in which, according to a document of 1507, there were enclosures for camels, ostriches and 'wild animals' imported from Spain, and lions were kept at the Nederhof. In 1516, there were sizeable herds of deer in another part of the garden, and in the same year, L. Guicciardini described ponds with rare fish and swans and meadows with wild animals that could be observed, like some exotic world, from the windows "from various parts of the palace." Charles V had a summer-house built here so that he could live in this other world.

The labyrinth in the same park was a man-made place of stylised nature. The *feuillée*, as the labyrinth was called in Charles' time, was a copse "of unprecedent artifice and variety," as a Spanish traveller wrote in 1559. Charles had the bath-house here replaced by a wooden pavilion built on eighteen marble columns, which can be seen in Dürer's drawing. The palace, in which he had spent his childhood, became his favourite residence outside Spain and he devoted much time and energy to the gardens, in which he spent as much time as possible. This natural Paradise was bounded by garden walls like a picture within a frame.

At their villa in Castello, the Medici reconstructed early zoological gardens of this kind with stone sculptures of animals. In her study of this Florentine *illus. page 104* garden, Claudia Lazzaro speaks of animals as 'cultural signs' in a complex system of references in which *natura* was constantly pitted against civilisation. The untamed forces of nature were represented by the wild and exotic animals, while controlled nature was represented by domestic animals and pets. Keeping both kinds of animals presented a programme that expressed the

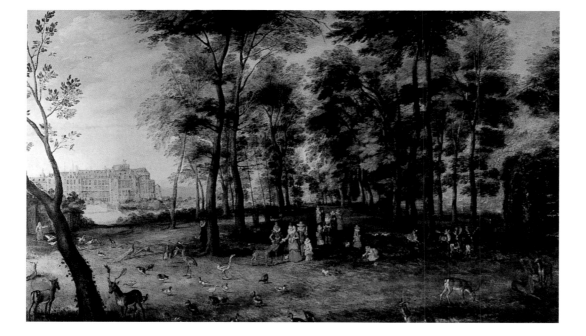

Archduke Albrecht and Archduchess Isabella in Coudenberg Gardens in Brussels, c. 1630
Rubenshaus, Antwerp

Albrecht Dürer
The Coudenberg Gardens, 1520
Pen and ink drawing
Kupferstichkabinett, Akademie
der Bildenden Künste, Vienna.
The hand-written comment means:
"This is the zoo and pleasure garden in
Brussels, seen from behind the palace."

synthesis of nature and civilisation as well as the contrasts between them. Courtly rule was thus extended to the symbolic dominion over nature itself, as represented in the *pars pro toto* of the gardens. Such gardens were, at the same time, related to the literary inventions of Paradise which were inspired by them, so that the boundary between the fiction of paradise and the reality of the garden remained fluid. Bosch's painting, with its utopian vision and social critique, also belongs to this panorama of imaginary worlds.

Yet even the boldest imaginings were overshadowed in those days by reports from the New World, tangibly illustrated by way of royal acquisitions and trophies. They triggered a crisis in the way people saw the world – a world in which Paradise had once had a place – and shifted the boundary between fact and imagination which, until then, had so protectively scintered the domain of imaginary worlds. Even though Bosch's painting was little effected, it was inevitable that it should be measured by this new yardstick. The discoveries also disclosed a hitherto unknown (non-Western art) that not only demanded the protection of a Western concept of art, but even favoured, probably for the very first time, a general self-reflection on the notion of art. In this respect, Bosch's painting might be regarded either as already outdated or as symbolising a world in which anything had become possible.

Dürer, in Brussels, waxed enthusiastic about the strange artefacts that had so little in common with his own art and culture, and spoke with unbiased generosity of the "wonderful things of artifice" created by the "subtle ingenuity of people in foreign lands." Weapons, strange, feathered garments and cult symbols such as a sun wrought in gold, could all be seen in the Brussels residence,

Grotto with a menagerie
of stone animals
Villa Medici in Castello, Florence

where they vied with the adjacent zoological garden and the labyrinth like competing dreams. Perhaps the artefacts in questions were the gifts that Hernán Cortés had received from the Aztec ruler Montezuma on his first expedition in 1518. That would explain the fact that they were mentioned as being in Seville in 1519. Charles V bequeathed them to the Regent in Mechlin, who listed them in an inventory and displayed them in her library. Similar objects had been in the possession of the Spanish monarchy since the time of Columbus. Serge Gruzinski, who traced the reception of these New World artefacts in the Old World, noted that there had been an initial phase of admiration and aesthetic curiosity, in contrast to the later iconoclastic destruction of Aztec art initiated by Cortés. Peter Martyr d'Anghiera, the Milanese who was chief chronicler of the West Indies at the Spanish court until his death in 1526, may well have been responsible for the explanatory commentaries offered to Dürer as a tourist.

Certainly, Dürer employs the self same clichés which, in colonial reports, used terms of speechless admiration to gloss over a certain bafflement ("and of these things I know not what to say"), thereby dispensing with any form of classification. Peter Martyr also relied on the reports of those returning from overseas in order to write his commentaries on the impressive artefacts. Since art, in those days, was generally judged by its imitation of nature, he had to acknowledge the achievements of the Aztecs in this respect, even though their approach to nature was very different indeed. Dürer did not even attempt to capture these objects in drawings, which would have been 'art after art,' rather than art after nature.

The "new golden country," as Dürer called Mexico, conjured up in the mind's eye a notion of unknown regions which defied imagination, even though they were known to exist beyond the ocean. Such notions were inevitably enriched by images of a Paradise where people still lived in a state of natural innocence. After all, they had been discovered beyond the bounds of history and culture that had been drawn mentally around the Old World. The yearning of the modern age for so-called 'primitivism' inherited the ancient dreams of imaginary Paradise. The dreams of Africa and Oceania, for instance, long resisted the colonial reality of these worlds.

Hendrik of Nassau was as susceptible as any to the lure of the exotic. He may well have stood in front of Bosch's triptych, together with the emperor who was once his charge, wondering whether the kind of Paradise portrayed by

Aztec feather skirt among the booty
plundered in 1518
Kunsthistorisches Museum, Vienna

Bosch could really have been part of the divine scheme of Creation. Hendrik, who often visited the Brussels residence, was familiar with the objects brought back from the New World. A letter he wrote from Spain in 1522 to his brother in Germany (p.79) betrays his fascination with the New World. One year earlier, Cortés had conquered the Mexican capital Tenochtitlán. This is the subject of the letter. It begins by stating that, once again, 'a new island and landscape' had been discovered overseas, comparable in size to Europe. Could it be that, in claiming a monopoly on the images and dreams of a far-flung Paradise, the military and the missionaries were colonising not only the New World, but also the European mind? It was an issue that prompted poets and writers to launch counter-strategies, plying their readers with fictitious travelogues more eloquent and imaginative by far than than the reports from the new colonies and untainted by the scandal of colonisation. The first example of this new form of literature is the one that gave the entire genre its name: Thomas More's imaginary island of *Utopia*, set in the New World, but as yet untouched by colonisation.

Sir Thomas More (1478–1535) first published his fictitious account of a journey to the island of *Utopia* in 1516, the year of Bosch's death. Bosch therefore cannot possibly have known of or been influenced by the ideas contained in it. Yet there is every reason to include the subject here, setting aside all thoughts of who was influenced by what, and to ask ourselves which of the prevailing ideas of Bosch's time can be associated with his work. The utopian vision of a perfect society formed a literary counterpoint to Bosch's vision of paradisical humanity and, though it had a similar impact on the imagination

Thomas More
Title page to his work *Utopia* in the Basel edition published by Joh. Froben, 3rd edition, 1518
woodcut by Ambrosius Holbein

of his contemporaries, differed in some important ways from his biblical fantasy. More's island is no more a part of this world than Bosch's paradise. Indeed, this is precisely why he coined the Greek-derived term *U-topia* (No-place) in his quest to forge a literary code for his fictitious republic. In a letter, to which we shall return later, he defends the existence of the island by explaining that, although he could have made things easier for himself by not using the Greek neologism and simply by saying that 'the island is nowhere' (*nusquam*), (p. 111) it doubly confirmed the fiction for those in the know. By couching his own social ideals in fictional terms, he skilfully developed a literary awareness of fiction that he shared with his friends and readers. This awareness opens up a potential new angle on Bosch. What is more, in the garb of fiction, the concept of art in the early modern era was taking shape in a way that emancipated art from its mere obligation to imitate visible reality and gave the artist's imagination free rein in his own medium.

First of all, however, something must be said about the method behind More's *Utopia*, so that it can be placed more clearly in the context under discussion. The author does not actually travel to Utopia himself, but merely presents the report of a Portuguese visitor to the island in the New World. In this way, More introduces just the kind of ambiguity of fact and fiction that Bosch also worked with. Utopia may be in the New World, just as the biblical Paradise may be on earth. The islanders might have achieved an ideal form of society, just as man might have stayed in Paradise. In both cases, what we wish to imagine is presented as fact, which can be narrated or painted. At the same time, the reader or spectator is aware that the narrative in the travel report and in the painted view are based on fiction. In both cases, the utopian vision is merely the reversal of a social critique which, in More's case, openly addresses the Commonwealth in the greater part of Book I. The analogies, if they can be described as such, between the painting and the book end here. However, let us bear Bosch in mind when we allow More to introduce us to the character of fiction.

Fiction and fact are inextricably linked from the very moment More begins describing the creation of the work. Sir Thomas More was indeed in Flanders on a diplomatic mission in the summer of 1515 and he did stay at the home of the editor and Antwerp town clerk Peter Giles (1486–1533), with whom it would seem that he developed the plan for the story. It was then, he claims, that Giles had brought him in contact with the traveller Raphael Hythlo- *illus. page 119* daeus, whose name any scholar of Greek would immediately recognise as 'one well-versed in nonsense.' This imaginary traveller introduces a fictional aspect into a situation that actually existed in both time and place. In the introduction, the author tells how, after attending a church service, he happened to meet Giles on the street, and was introduced by him to the mysterious traveller. Returning to his lodgings, they sat together on a grassy

bank and Raphael told them of the island republic where wisdom and justice ruled and where they had no private property. The narrative is clearly a tongue-in-cheek reference to the latest travel reports from the New World, which were often given more credence than they deserved.

Perhaps three men really did sit chatting in an Antwerp garden. If so, the third man, however, was not a Portuguese adventurer, but their mutual friend Erasmus of Rotterdam, who, as we know, scrupulously edited the first publication of the book in 1516 and added his own invaluable commentaries. Replacing a real-life friend with a fictitious traveller meant carefully erasing the presence of the former in the conversation, so that only More and Giles could recall the memory. This aspect will be analysed later to reveal a different facet of the work's fiction (p. 113). In the meantime, however, let us consider the circumstances under which it was purportedly created. Together with the text of 'our Utopia,' the author sent his friend Giles a letter which was included in the printed version as a preface. The letter calls upon Giles to confirm that he had merely recorded verbatim a narrative that they both listened to. In it, he then, rather slyly, asks his friend whether he recalls the width of the bridge across the river Anydros ('Nowater') on the island. He also suggests that Giles should ask the Portuguese traveller, either by letter or by word of mouth, to give him precise information as to the geographic location of the island of Utopia. "We never thought of asking ... whereabouts in the New World Utopia is," for there were already people eager to go there. This sleight of hand, as Carlo Ginzburg recently described it, was in the tradition of the satirist Lucian of Samosata (c. 120–180 AD) whose writings Erasmus and his friend Thomas More had translated from the Greek.

The Greek names and terms included in the portrayal of Utopia are an important indicator of this source. At this point, the correspondence with the *True Histories*, in which Lucian presents a fictitious travel report, should be pointed out. The introduction launches a jibe at all writers and philosophers who have proffered their fabricated tales as facts, while he himself is truthful enough to admit to his lies, in writing about things that he has neither seen for himself nor heard from others. Erasmus and More can hardly have overlooked the fact that Lucian's sea voyage also began at the very same place in Spain from which the colonisers also departed. After eighty days, the seafarers finally reached a high, wooded island where, on their first tour, they discovered an inscription announcing that Hercules and Dionysos had come this far. More played with this literary topos by continuing his own journey of the imagination along Lucian's path towards the imaginary worlds. Lucian, for his part, met Ulysses in the second book of his *True Histories*, before discovering the 'Isle of Dreams' which was "unclear and, as in a dream, moved further away the more one believed that one was approaching."

Erasmus of Rotterdam bears witness to Lucian's enormous importance for the author of *Utopia*. He praises his 'dearest friend' Thomas More, claiming that he blended wit and earnest with the incomparable skill of a second Lucian. Lucian, too, says Erasmus, "tells the truth with a smile and laughs as he speaks it. He paints the mores and feelings of people as though with a brush, so that one believes one is seeing them with one's own eyes even as one reads of them." The simile of the artist's brush is applied by Peter Giles in the same sense when he explains Thomas More's *Utopia* in a letter to Hieronymus Busleiden. "At present very few people know about this island, but everyone should want to, for it's like Plato's *Republic*, only better. He sets it all so vividly before one's eyes that, by reading, his words seem to provide an even clearer picture of it than I had when Hythlodaeus' voice was actually sounding in my ears." The artist's brush wielded by More had painted the island with such deceptive reality that the author surpassed not only Ulysses but even Amerigo Vespucci. Any scholar of Erasmus' writings would surely have recognised the reference to Lucian, described as precisely by Erasmus as the author of *Utopia* was described by Giles. The letter to Busleiden was included in the very first edition of the work, together with the response that he envied the Utopian republic its constitution. In this way, he played along fully with the ambiguous interaction of fact and fiction. Since Bishop Busleiden was a member of the innermost circles of the Burgundian court, *Utopia* was obviously known soon after publication by people in the circle around Hendrik of Nassau. It was Busleiden who commissioned Erasmus in 1518 to establish a trilingual college at the University of Leiden.

The simile of the artist's brush is also a reference to the descriptive approach in classical literature known as *ecphrasis*, which aimed to evoke a work of art or a beautiful landscape so lucidly that the reader felt he could actually see what he was in fact merely reading. Yet the significance of the reference is even more far-reaching than Carlo Ginzburg assumed. While the description of a painted picture presumes the existence of that picture, there were some who realised that the image in question could also be fictitious and that it was the description that turned the fiction into fact. This process was eloquently applied to the island of *Utopia* by declaring the description to be the description of an image. The classical comparison of literature and painting implied in this discourse also had an impact on contemporary understanding of the fine arts. If this analogy was to be taken seriously the other way around, painting would have to be granted the same right to draw upon fiction. That is just what Bosch did – not only the fiction that is inherent in any painting of reality, but also the fiction of freely inventing something that exists only as a painting.

In another letter to Giles, included in the second edition of *Utopia* in 1517, Thomas More muses on the rather obvious question of whether the island is

fact or fiction. After all, had he intended merely to write about a just state, he could easily have turned his attention to fiction and sketched a more pleasing version of the truth. The fiction would then have been so evident that the reader would have seen through it immediately. In this case, there would have been no need to use the device of a travel report, for it would have sufficed to tell the reader that "the city is a phantom, the island nowhere, the river dry and the prince without subjects." He himself had paid tribute to a historians sense of truth and this had been the reason why had been obliged to use the "barbaric and nonsensical names" that appear in his work.

The fiction that More used is couched within a lengthy explanation of why it cannot possibly be fiction. It is a construct of enormous virtuosity in which More surpasses even Lucian, who openly admitted to fiction. At the same time, the fiction was carried by the consensus of a circle of like-minded friends who had agreed to the rules of the game. This is why the letters of his accomplices are included in the book. In the French edition, this network of consensus also included a letter from the humanist Guillaume Budé which says of the island of Utopia, which could also be called 'Never' (Oudepote) that, unlike Europe, it has upheld wisdom and Christian values. The letter goes on to maintain that, since it is situated 'beyond the known world,' it may be one of the islands of the blessed. By claiming that the population is bound within the community of a 'sacred city' (Hagnopolis), Budé also introduces the aspect of celestial Paradise, generally associated with the Heavenly Jerusalem. Budé loves the author for what he has written about "this island in the New World." These letters spread the responsibility for the work among a number of people. The letters are not only the expression of a newly formed readership, but also the vehicle for a new discourse. The ideal world, no longer to be sought in the Christian afterlife, could only be found in fiction. Thus, from here on, it existed in a utopia that was the benchmark of how the world should be, rather than how the world actually was.

illus. page 107 In this respect, the visual arts also shared a new meaning, as they allowed the artist and spectator to become emancipated from social constraints. In the third edition of *Utopia*, in which Erasmus also had a hand, fine art took on an illustrative role by supplying a frontispiece and a coded picture of the author. Both are woodcuts created in 1518 by Ambrosius Holbein, brother of Hans Holbein the Younger, for the small-format edition published by Johannes Froben of Basel. The frame inscription lends the full-page cover picture the aspect of a painting or tableau: *Utopiae Insulae Tabula*. The island that presents a different world by using the circular schema of the earth surrounded by sea is accessible only by the ship which the traveller Hythlodaeus is pointing out to the author on the shore. But the ship has already sailed, and so it is a ship of the imagination, on which we can travel only in our

thoughts. The fictitious narrator, an invention of the author, sends the reader on a journey of the imagination, whose destination is known only to the imaginary narrator and the real author. And so the three figures on the shore, of whom only Hythlodaeus can claim to have been on the island, each has his own place in the overall plan of the work. The author narrates with the voice of another and the reader can only travel by reading.

FICTION AND HUMANIST PORTRAITURE:
AN EXCURSUS

illus. page 114 The second woodcut in the Basel edition, an illustration in the text, portrays the conversation in the garden, on which the description of the Island of Utopia is based, as though it had actually taken place. Thomas More and Peter Giles are listening to Hythlodaeus' report of his journey to the island from which he has recently returned. The inscription identifies the figures in the picture and, in doing so, conceals the fact that the narrator, unlike his listeners, is fictitious. However, the other two are more than mere listeners, for they are dressed in the garb of poets. To the left, the author's student enters the garden. In the centre, in front of a rosebush, the sumptuously attired author, Thomas More, stretches out his arm towards Hythlodaeus as though to confirm his existence. In his other hand he is carrying something resembling a musical instrument. Peter Giles, the robed host, is listening to the wanderer's story with an expression of astonishment. The clothes of the traveller and his long beard of seniority make the fictitious narrator the odd man out in this group. Since Hythlodaeus is an invention of the author of *Utopia*, the conversation in the garden, where More allegedly recorded the stranger's travel report word for word, must also be an invention.

Nevertheless, the group of three men in conversation is not quite as fictive as it appears if we substitute the exotic traveller for the very real person of Erasmus of Rotterdam, who is known to have been involved in the conception of *Utopia*. Whereas Giles, who entertained Erasmus even more frequently than Thomas More, was what we would nowadays call the editor of the Louvain first edition, Erasmus was the editor of the Basel edition and, even before that, played such an important role in the creation of the work that, when More wrote to him in December 1516 in anticipation of the forthcoming publication of the work, he spoke of "our Utopia" and said that it was "based on your writings." Yet Erasmus is not mentioned at any point in the text or the dedication of *Utopia*. The reasons for this can be reconstructed. Raphael was not a pseudonym for Erasmus, but was a fictitious figure necessary to the internal structure of the work, so he did provide a subtle hint that there had been a third person involved in composing the tale. His fictional presence placed him firmly within the humanist sphere of role-play among the members of a kind of secret society who sometimes even used painted portraits as a vehicle for their literary fiction.

In order to explore Erasmus' connection with *Utopia*, we have to return to *The Praise of Folly,* which Erasmus thought up on his way back from Italy, but did not actually write down until he was in England in 1509 as the country

Io.Clemens. Hythlodæus. Tho.Morus. Pet.Aegid.

Ambrosius Holbein
Woodcut, in the Basel edition of *Utopia*
published by Joh. Froben, 1518

house guest of Thomas More (p. 96). The Greek satirist Lucian, whose writings More and Erasmus had translated, was as important an influence on this work as he would later be on the composition of *Utopia* (p. 109).

The Latinised Greek title *Encomium Moriae*, which Erasmus shows for his Latin text, is in fact a pun on the name of the friend to whom he dedicated *The Praise of Folly*. In his dedication, he freely admits to this pun, based on their mutual literary preferences. "I thought that this flight of my imagination would not give you displeasure." The idea for the work had, he explained, been an attempt to conjure up the conversations with More that Erasmus had enjoyed so much. This is why Erasmus, in his dedication, backdates the writing of the book to 1508, while he was still in Italy. There are no pictures in this edition, though Erasmus later had his own copy illustrated with drawings by Holbein.

Recalling past conversations is a theme that recurs in the introduction to *Utopia*. From May to October 1515, Thomas More had stayed in Bruges as part of an English trade delegation, and had visited Antwerp, where Erasmus was also a guest at the house of Peter Giles. It was during this visit to Flanders that the notion of a fictitious state was developed as a kind of pastime, prompted in part by a sense of resignation at contemporary society. In both the introduction and the dedication, More refers explicitly to Giles as his 'witness' to the travel report from Utopia, but he does not mention Erasmus at all. This omission is all the more interesting, since Erasmus was actually in Antwerp in May 1515 and met More in June.

During the same period, Thomas More wrote another, very different work, which focuses entirely on Erasmus. It is an open letter to the theologian Martin

van Dorp, who had published a polemical attack on Erasmus at the University of Louvain. Although Erasmus and More jointly wrote this open letter, More is the sole narrator and author, defending Erasmus in a situation that could have proved dangerous for him. More defends Erasmus' theological stance and justifies his work on the New Testament. Erasmus, however, was in danger not only in theological circles, but also in the political realm. In 1515, also in Louvain, he had published his *Education of a Christian Prince*, dedicated to the young ruler Charles who had recently come of age. In its radical critique of the prevailing power structures, it was a work more utopian than *Utopia* itself, demanding that a just state be established here and now. Even Hendrik of Nassau mocked his idealism. According to Erasmus, people were 'free by nature' and the state would continue to exist even without a ruler, for rulers were only there in order to serve the state. The utopian ideal lay in the notion of actually educating the heir to the throne so quickly, by means of such a text, to become a perfect head of state.

The fate of this text would have been jeopardized if Erasmus had been associated with the dream journey to Utopia, in which his thoughts were presented in a Lucianic masquerade that was more likely to raise a laugh than to provide a practical guideline for education. This co-incidence of time and content was reason enough to conceal Erasmus behind the exotic figure of the traveller, whose fantastic report would have undermined Erasmus' educational concept. In addition, Thomas More, a pragmatic man, knew well that his own authorship would have been cast into doubt had he involved his famous friend Erasmus in his work. Peter Giles, on the other hand, was not an author, and so he was more suited to the role of eyewitness confirming the (fictitious) conversation in the garden. This explains why *Utopia* is dedicated to Giles and not to Erasmus.

The same group of friends so often linked by a fictional presence is formed again two years later in the portraits that Erasmus and Giles sent to their friend More. More received them in Calais, where he was on yet another mission, though they were destined for his house in London. This time the situation is reversed: it is the third man in the group who is physically present when he looks at the pictures and recalls his conversations with the other two – conversations originally conducted in their presence. On the other hand, the other two sought to converse with their absent friend through a medium not necessarily using the public realm of literature. This time, the fictitious presence of a personality is entrusted to painted portraits which, this time, were also employing literary references and thus making the connection to written correspondence. In his famous essay, Stephen Greenblatt points out the analogy between Holbein's painting *The Ambassadors* and the contradictory, paradoxical approach of *Utopia*. The gifts made to one another by the friends

involved in creating *Utopia*, by which they expanded their literary horizons and redefined portraiture, should also be borne in mind at this point. On 30 May 1517, Erasmus notified More of the dispatch of the double portrait in the same letter in which he says that he has just sent the text of *Utopia* to Basel for a new edition.

Several copies of the two portraits have survived and they seem to have been distributed widely in the form of replicas. Today, there is, however, agreement that the paintings in the Royal Collection at Hampton Court and in Lord Radnor's collection at Longford Castle are in fact the originals. According to Erasmus' letter, it was originally intended that the portraits be painted on a single panel. They were then composed as a diptych, which meant that Thomas More could create a fictitious triptych in his mind when he contemplated them. The two painted humanists are looking towards each other, albeit without eye contact, for their inner eye is directed towards the absent friend whose memory they cherished just as their portraits are intended to remind him of them.

illus. pages 118/119

It would seem that the thematic approach of the two portraits was discussed in detail with the Antwerp artist Quentin Massys. Erasmus is shown in his role as author, in the act of writing a manuscript. Giles, on the other hand, is presented as a reader, gesturing with his right hand towards the book by Erasmus. In his other hand, he has a letter from More, indicating his involvement in the literary correspondence between the two friends. There is also a clerical touch that distinguishes Erasmus from the wealthy man-of-the-world Giles. Their expressions reflect their vivid minds, but their faces also bear witness to their failing health, which is an important topic in all their letters of the time.

Once, Erasmus was even sent home when the artist found his face changed by illness and was asked to return later for another sitting. The fiction of reality goes so far that the painter has even emulated Erasmus' own handwriting in the book. The books on the shelves and on the desk not only recreate the atmosphere of the study, familiar from images of St Jerome, but also point to a shared intellectual world, as indicated by the titles. Lucian, who was such a major influence on *Utopia*, is shown alongside *The Praise of Folly*, which Erasmus dedicated to Thomas More. Giles has on his desk an edition of the *Education of a Christian Prince* (p. 115), as though to say that Erasmus had created in this work a stringent counterpoint to *Utopia*. The three friends continue their conversation via the fiction of the portrait.

Erasmus appears as a reincarnation of St Jerome, whose writings he had published the previous year in a new edition. He is entirely surrounded by a panelled study, with light falling through the window in front of him. His physical likeness is evident only in the contemplative expression and in the fine hands placed on a manuscript. On a red velvet cushion is his commentary

on Paul's Letter to the Romans, which he was working on when the portrait was started. The word *Epistula* also recalls the literary genre of the letter – the medium by which the three friends corresponded. The eyes of the author are not focussed on the text. With a faint smile, he is gazing into the distance, as though seeking to converse with his English friend about the commentary. Instead of concentrating on writing, Giles has turned towards the spectator, the recipient of the painting, from whom he has just received a letter, as though in conversation. On the rolled-up letter it is just possible to read the salutation *V(iro) Illustrissimo Petro Egidio Amico Carissimo Anverpio* (illustrious gentleman and dear friend Pieter Egid in Antwerp). Not one of the books on the shelves refers to the editorial involvement of the Antwerp scholar, since they are all recent publications by Erasmus.

There are few portraits of this period of which we know so much, for no less than ten letters and two poems address them. Erasmus announced the portraits in May 1517, but the project was delayed by the illness of Peter Giles. More wrote in June that he was looking forward to receiving the portraits. But on 1 August 1517, Erasmus asked his friend in Antwerp to put some pressure on the artist to finish the work. On 8 September, Erasmus wrote that he was now sending "the panels, so that through them we are with you, even if death should take us away." In his letter, he mentions that he has shared the artist's fees with Giles, not in order to save money, but to ensure that it is indeed a joint gift. On 16 September, a letter from Erasmus says, "I have sent myself (to you)," meaning that the portraits had been despatched to Calais, where More was staying.

In early October, More replied with a draft of two poems written for the portraits. These, he claimed, would 'double the wonder' of the painted figures when they were written alongside the portraits. If Giles approved of the texts, he would send them to Erasmus. Otherwise, he would throw them on the fire. With his literary response to the painted gift, More himself became involved in the portrait project. The reactions from Antwerp and Louvain were positive. One poem had the heading *Tabella loquitur* (the painting speaks). Even though the friends were separated, they were still linked by the spirit of friendship. The 'dear letters' they wrote to each other carried their thoughts in the same way that the painting carried their bodies. In another poem, More himself speaks (*Ipse loquor Morus*). Anyone who had ever seen these friends would recognise their faces again. Otherwise, their written word would represent them. The books quoted in the portraits "because they are famous throughout the world" betrayed the names of those portrayed, even though they are silent in the picture. Like a new Apelles, the painter "simulated life in lifeless effigies" (*vitam ad fingere*) and in the fiction of their bodies surpassed even classical antiquity, which was always the highest aim of the humanists in their literary language.

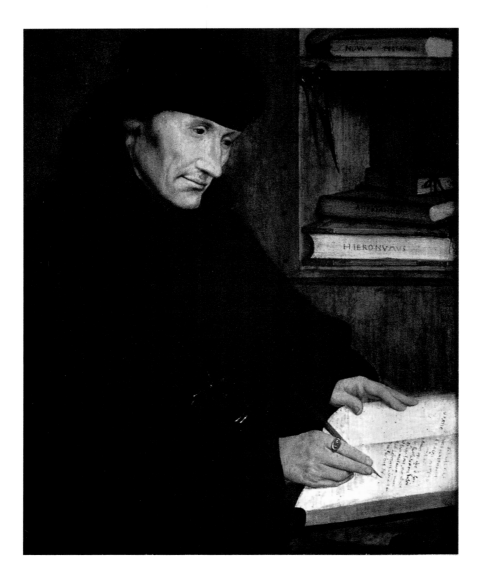

Quentin Massys, *Portrait of Erasmus
of Rotterdam*, 1517
The Royal Collection, Hampton Court
© 2001, Her Majesty Queen Elizabeth II

The historical impact of these portraits on literature and painting is well known. It was evident in Erasmus' decision, just two years later, to have Quentin Massys create a portrait medallion with a complex programme for him. A year later, in 1520, when Dürer was travelling in the Low Countries, he sketched Erasmus and subsequently used the drawing as the basis for his famous copperplate engraving of Erasmus with accompanying verses that elevate the idea of the portrait to new heights, using a graphic medium that could be distributed as widely as printed literature. The double portrait of Erasmus and Giles was seminal to the reinvention of the genre.

Only Thomas More was excluded from this medium because, living in England, he had no access to an artist of this calibre. The opportunity did not arise until Hans Holbein the Younger came to England in 1526. In the previous

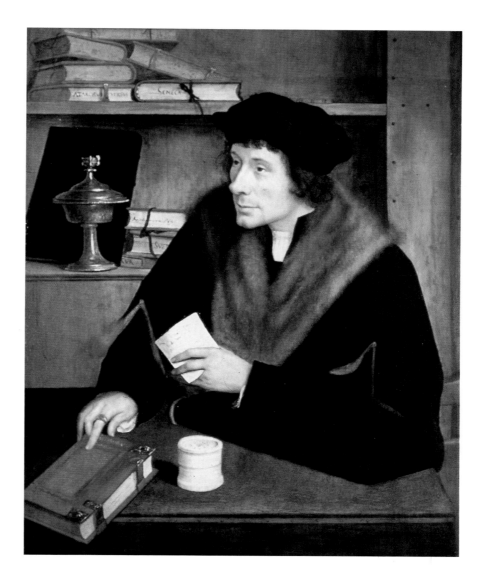

Quentin Massys, *Portrait of Peter Giles*
1517, Longford Castle, The Collection
of the Earl of Radnor

Pages 118/119
The two paintings were a present
to Thomas More who, as an observer,
formed the third member of the trio.

years, he had executed a number of portraits of Erasmus on behalf of the Basel-
based publisher Froben, and had also worked on the illustrations for *Utopia*
and *The Praise of Folly*. Erasmus now gave him a letter of recommendation
from Basel asking Giles to introduce Holbein to the artist Quentin Massys in
Antwerp, so that they could discuss their respective approaches to portraiture.
In England, Holbein was the guest of Thomas More, now Chancellor of the
Duchy of Lancaster, at his recently purchased home in Chelsea. But another
year was to pass before Holbein completed the first official portrait of his host.
The picture now in the Frick Collection in New York gives a good impression
of how it must have looked. In a drawing, Holbein had captured the wit of the
blue-grey eyes that Erasmus had described with such enthusiasm in a letter to
Ulrich von Hutten. The painting, however, shows him as a statesman with all

Hans Holbein
Portrait of Thomas More, 1527,
© The Frick Collection, New York

the aloofness and dignity of his official position. More's solemn aura is further dignified by the sumptuous background drape. Seven years later, as is known, More stood trial for high treason. He was executed in 1535. Baldinucci reports that the original of the portrait was acquired by Henry VIII. Anne Boleyn, who had reason enough to have pangs of conscience about the man who had so honourably opposed her marriage, felt such deep fear when she contemplated More's portrait in which he "seemed still alive" that she threw it out of the window in anger.

SUMMARY

The new approach to portraiture addressing a literary public emerged within a circle of individuals in close contact with one another. Artists became involved in projects by writers and were given the opportunity of honing their own concept of art in dialogue with their counterparts. Although the humanists were a very different audience indeed in comparison to the aristocracy for whom the *Garden of Earthly Delights* was painted, there were certain links between the two circles, who commissioned very different but nevertheless mutually inspiring works from artists. The humanist themes in the circle of Erasmus and More were undoubtedly more modern than the themes addressed by Bosch, and yet Bosch, too, sought in his fiction a new domain of art in which he had more creative scope. Given that we know far more today about the humanists than we ever knew about Bosch and his patrons, it is worth examining their words, even though they do not refer directly to the painter.

This was not to change until several generations later, when Spanish writers such as Felipe de Guevara, Queveda and Fra Siguenza made their statements. In the Netherlands, writing on art in the years following Bosch's death focused entirely on Renaissance art and its cult of classical antiquity. Though the written word remains silent, the copies and fakes that abound bear impressive witness to Bosch's posthumous fame. There is a remarkable discrepancy between Bosch's popularity, which grew as time went by, and its mirroring in literature. One could go one step further and say that there is a no less remarkable discrepancy between Bosch's way of thinking, typical as it is for his time, and his form of art. Bosch was as far from conventional religious iconography, which he employed so subversively, as he was from the humanist iconography of the new era, which he did not use at all. Bosch's art thus had the same fascinating impact on his contemporaries as it had on later generations, inviting copies and counterfeits. Those who copied him merely confirm the suspicion that his art was linked closely to his person and that it never formed a general style. Peter Breughel the Elder is the only artist who might be said to have continued in the tradition he created, though he was already well established as a painter when he did so.

The Garden of Earthly Delights is a perfect example of the contradictions in Bosch's art which defies conventional iconography. The triptych takes the form of an altarpiece without ever having been an altarpiece, and employs biblical themes without reiterating the text of the Bible. The central panel, whose meaning has so long been a mystery, is the touchstone. It appears to show the biblical Paradise and yet it remains a fiction since the Paradise seen

here never existed. In other words, it is a question of discovering the fiction within the chosen theme, for all its biblical basis, and of grasping fiction as the timely expression of an art in search of poetic licence and freedom. This explains why Bosch was able to address the Paradise of Adam and Eve while disregarding the Fall from Grace. Indeed, the world void of human life, in the process of Creation, which is the theme of the outer wings, is far more unconventional that it might appear at first glance, considering the form of the work, for it acts as a prologue to the interior of the triptych. This is why the two views of the work, closed and open, actually served as the fulcrum point of a dramatic performance given by the Count of Nassau on social occasions. In the Palais Nassau in Brussels, the triptych formed part of an early original collection of exotica representing the natural and man-made wonders of the world.

Bosch painted the biblical Paradise as though it were the place believed by ancient geographers to lie in some inaccessible part of the world. Yet it is not the Paradise from which Adam and Eve were expelled after the Fall. Bosch's Paradise does not lie in a long-lost age, but beyond the bounds of time itself. Had he actually portrayed the Original Sin, Bosch would have situated the main picture in a past time. However, in the triptych, the Original Sin is inherent in the invisible transition to the Hell wing, where we see the world after the Fall, as Bosch understood it and as he experienced it in his own lifetime. Bosch's Hell is not in the next world, but in this one. This is evident in all the fraudulence and dishonesty, even though they are to be punished in the afterlife. The narrative structure of the painting has a thoroughly subversive yet stringent logic. The transition from the biblical setting, in the left panel, to the utopian, in the centre panel, employs a fictional narrative. The transition to the panel depicting Hell, by contrast, breaks the fiction with an abrupt return to reality – and a hellish reality at that. It is in this antithesis that he dismantles the fiction of a beautiful other-world.

It was around the same time that Sir Thomas More coined the term Utopia. In search of a name with an authentic ring of antiquity to describe his non-existent island, he turned to the fiction of ancient travel descriptions that were journeys of the mind to another, very different world. Not only does the island he describes lie in another era, but also in another place. The author bases his tale on the supposed account of a traveller recently returned from the island. Its inhabitants are not noble savages or natural innocents as described by Bosch, but members of a better civilisation whose life contrasts irreconcilably with that of European society. Though the island lies beyond the sea, it does not represent the New World, where colonisation was already taking its toll. Unlike the Americas, Utopia embodied a place of happiness that had long been the stuff of dreams. The ancient hope that one need but travel in order to find a better world was sustainable only in the realms of the imagination.

BIBLIOGRAPHY

GENERAL PUBLICATIONS ON BOSCH:

C. de Tolnay, H. B. (B. Baden 1965);
C. de Tolnay, H. B. (B. Baden 1965); G. Unverfehrt, H. B. Studien zur Rezeption seiner Kunst (Berlin 1980); D. Hammer-Tugendhat, H. B. Eine histor. Interpretation seiner Gestaltungsprinzipien (Munich 1981); R. H. Marijnissen, H. B. Das vollständige Werk (Cologne 1999). See also H. Belting, C. Kruse, Die Erfindung des Gemäldes (Munich 1994) p. 86ff.; J. L. Koerner, Bosch's Contingency, in: G. v. Graevenitz, O. Marquard (ed.), Kontingenz (Munich 1998) p. 245ff.; Jos Koldeweij et al (eds.), Exhibition catalogue 'Jheronimus Bosch. Alle schilderijen en tekeningen' (Rotterdam, Museum Bojimans Van Beuningen 2001).

PUBLICATIONS ON
GARDEN OF EARTHLY DELIGHTS:

Belting – Kruse (see section A) p. 123ff. and 272f. with bibliography; J. Wirth, H. B. Der Garten der Lüste. Das Paradies als Utopie (Frankfurt 2000); P. Beagle, Der Garten der Lüste (Cologne 1983); J. und M. Guillaud, H. B. The Garden of earthly delights (New York 1988); P. Vanden-broeck, J. B. zogen. Tuin der Lusten, in: Jaarb. kgl. Mus. v. Schone Kunsten, Antwerp 1989, pp. 9-210 and 1990, pp. 9-192; J. Wirth, Le Jardin des Délices de J. B., in: Bibl. d'Humanisme et Renaissance 50, 1988.3, p. 545ff.; E. Kessler, Le Jardin des Délices et les fruits du Mal, in: Cahiers du Léopard 6, 1997, p. 177ff; M. Bergman, The Garden of Love, in: Gaz. Beaux-Arts 115, 1990, p. 191ff.; Marijnissen (see section A) p. 84ff.; I. M. Gómez, Analyse du triptyque, in: Guillaud (see above) p. 11ff. and 255ff.; R. Berger - D. Hammer-Tugendhat (ed.), Der Garten der Lüste (Cologne 1985); K. Moxey, The case of the Garden of Earthly Delights, in: N. Bryson (ed.), Visual Culture (1994) p. 104ff.; D. Kamper, Unmögliche Gegenwart. Zur Theorie der Phantasie (Munich 1998); Pilar Silva Maroto, ed., El jardin de las delicias de El Bosco. Copias, estudio tecnico y restauraciu (Exhibition catalogue Prado 2000).

A TALE OF FASCINATION

A. Breton, Art Magique (1957); P. Beagle (see section B). On Fra Siguënza p. J. Snyder, Bosch in Perspective (N. J. 1973) p. 34; J. de Siguënza, Historia de la Orden de p. Geronimo, ed. J. C. Garcia (Madrid 1909) vol. 2, p. 635ff.; Tolnay (see section A) p. 401ff. F. de Quevedo, Die Träume (Frankfurt 1966) p. 36 and Wirth, 2000 (see section B) p. 20f. On W. Fraenger cf. I. Weber-Kellermann, ed, W. Fraenger, Von Bosch bis Beckmann (Cologne 1985) p. 15ff. and 332ff. (Biography). On the theme of alchemy cf. among others J. van Lennep, Art et Alchimie (Brussels 1966); J. Chailley, J. B. et ses symboles (Brussels 1978) and M. Yourcenar, Die schwarze Flamme (Munich 1991).

IN A PAINTED LABYRINTH OF THE GAZE

On the creation of the world cf. Belting – Kruse (see section A) p. 126. – On Adam's nomenclature and ur-language see U. Eco, The Search for the Perfect Language (London 1993). On Exoticism cf. G. Pochat, Der Exotismus während des Mit-telalters u. der Renaissance (Stockholm 1970); on Cyriacus and his circle cf. Ph. W. Lehmann, Cyriacus of Ancona's Egyptian Visit and its Reflections in G. Bellini and H. Bosch (New York, n.d.). p. 17 (Rizzoni), p. 15f. (Bosch) and fig. 47 (Schongauer); R. A. Koch, M. Schongauer's Dragon Tree, in: Print Review 5, 1976, p. 115ff. On the twelfth-century versi-on of the Tundalus legend A. Wagner, ed, Visio Tundali (Erlangen 1882). R. Hammerstein, Diabolus in Musica (Berne 1974) p. 106ff. On Bosch's drawings in the Albertina (27.7 x 21.1 cm) cf. Tolnay (see section A) p. 389 and fig. 323.

THE ARTIST IN HIS HOME TOWN

Detailed study with new findings: Jos Koldeweij, Jheronimus Bosch in zijn stad, in: exhibition catalogue Rotterdam 2001 (see section A.) p. 20ff. Cf. also P. Gerlach, Les sources pour l'étude de la vie de J. B., in: Gaz. Beaux-Arts 71, 1968, p. 109ff.; J. K. Steppe, in: J. B. Bijdragen (1967) p. 5ff; Marijnis-sen (see section A) p. 11ff.; on membership in the brother-hood cf. G. C. M. van Dijk, De Bossche Optimaten (1973). On the Guevaras text cf. X. de Salas, El Bosco en la literatura espanola (Barcelona 1943) p. 9ff.; Snyder (see section C) p. 28ff. On Bosch's reception cf. L. Silver, Second Bosch. Family resemblance and the marketing of art (1998). On the Bosch paintings owned by Guevaras cf. J. Folie, in: Bull. Inst. R. du Patrimoine artistique 6, Brussels 1963, p. 183 ff. On Antiphi-los and grylloi painting see Pliny the Elder, Natural History XXXV.114. On the 'Baldus' epic which appeared in print in 1517 in Venice, and on the 'macaronic' style see B. Croce, Poeti e scrittori del Rinascimento 1 (Bari 1945) p. 154ff. and E. Bonora, in: Giornale Storico d. Letteratura Italiana 132, 1955, p. 1ff. On the 'Ship of Fools' Cf. Belting-Kruse (see section A) p. 90f. and plate 255. On Sebastian Brant, Das Narrenschiff, see the edition by H. J. Mähl (Reclam Univ. Bibl. 1992) with bibliography and the definitive edition by F. Zarnke (Leipzig 1854) (there p. 250ff. the texts by the Strasbourg preacher). On Bosch's drawings cf. Tolnay (see section A) p. 387ff. with illustrations, and Marijnissen (see section A) p. 453ff., for an interpretation of the drawing of the forest see Koldeweij (as above) (there in the catalogue the findings on the figure of the vagabond as part of the triptych.)

IN THE PALAIS NASSAU

On the portrait of Hendrik at the Kimbell Art Museum (57.2 x 45.8 cm) cf. S. Herzog, J. Gossaert called Mabuse, Diss. Bryn Maur 1968, p. 130 no. 21; V.I. Stoichita, Das selbstbe-wußte Bild (Munich 1998) p. 237; For more details cf. A. Mensger, Tradition und Aufbruch. Das Werk von J. Gossaert (doctoral thesis Heidelberg 2000) in print. Ibid. on Philip of Burgundy, plus the biography by J. Stark, Philips van Bour-gondië (Zutphen 1980). On Hercules and Deianira see Anto-nio de Beatis (see below) and in Gossaert's oeuvre cf. Mens-ger (op. cit.) plus Herzog (op. cit.) p. 88ff no. 57 and R. Kray, cf. Oettermann, Herakles/Herkules (Basel 1994) no. 1848. On A. De Beatis cf. Gombrich (see above, 1967) and L. Pastor, Die Reise des Kardinals Luigi d'Aragona ... beschrie-ben von A. de Beatis (Freiburg 1905) p. 64f. and 116f. plus J.R. Hale, The travel journal of A. de Beatis (London 1979) p. 93f. On the document un Lille cf. R.H. Marijnissen (see

section A) p. 13. On the Viennese Last Judgement triptych cf. R. Trnek, Das Weltgerichtstriptychon von H.B. (Vienna 1988). On Dürer's travel journal cf. H. Rupprich (ed.), Dürers Schriftlicher Nachlaß vol. 1 (Berlin 1956) p. 155.

On collecting and the emergence of the cabinets of art and curiosities cf. Th.H. Lunsingh Scheurleer, Early Dutch Cabinets of Curiosities, in: O. Impey A. Mac Gregor (ed.), The origins of museums. The cabinet of curiosities (Oxford 1985) p. 115ff.; H. Bredekamp, Antikensehnsucht und Maschinenglauben (Berlin 1993); M. Kemp, in: C. Farago (ed.), Reframing the Renaissance (Yale Univ. Press 1995) p. 177ff. On Margarete's collection cf. the as yet unpublished habilitation thesis which Ms. D. Eichberger was kind enough to allow me to study: Die Sammlung Margaretes von Österreichs. Mäzenatentum, Sammelwesen und Kunstkennerschaft am Hof van Savoyen in Mechlin (Saarbrücken 1999). On the Nassaus' town house cf. Th. Roest van Limburg, Voormalige Nassausche Paleizen in België, in: Onze Kunst 12.6, 1907, p. 79ff. and K. Vetter, Am Hofe Wilhelms van Oranien (Stuttgart 1990) with a reproduction of Schoor's painting. On the neighbouring residence cf. K. De Jonge, Het palais op de Coudenberg te Brussel, in: Belg. Tidskrift voor Oudheidkunde 60, 1991, p. 5ff.

On early copies of Bosch's painting see Unverfehrt (see section A) p. 91f. no. 161 and P. Silva. On the tapestries cf. Kurz, Four Tapestries after H. Bosch, in: Journal of the Warburg and Courtauld Institutes 30, 1967, p. 150ff.; V. en Guy Delmarcel, Kgl. Pracht in Couden zijde. Vlaamse Wandtapijten van de Spaanse Kroon (Amsterdam, exhibition catalogue 1993) p. 91ff.; P. Silva Maroto (see section B) no. 1–5. P. Junquera de Vega C. Herrero Carretero, Catalogo de Tapices del Patrimonio Nacional I (Madrid 1986). On the Parisian inventory cf. Schneebalg Perelman, Richesses du garde meuble parisien de François I., in: Gaz. des Beaux-Arts 78, 1971, p. 289f.

A GAP IN THE BIBLE

On Bosch's triptychs cf. L.F. Jacobs, The triptychs of H.B., in: Sixteenth Century Journal 31.4, 2000, p. 1038ff.; on the genre of the triptych cf. A. Neuner, Das Triptychon in der frühen Niederländischen Malerei (Frankfurt 1995) with literature list. On the Viennese triptych of the Last Judgement cf. Trnek (see section F.), on the Haywain triptych. Unverfehrt (see section A.), who regards the version in the Prado as a copy, with a discussion of he various versions, also Koerner, 1998 (see section A.) p. 264ff. and Marijnissen (see section A.) p. 52ff. On the discussion of the Biblical basis of our work cf. Belting Kruse (see section A.) p. 123ff. with references and Wirth (see section B) p. 43ff. On the Biblical depiction and the history of the concept of paradise cf. Reallexikon für Antike und Christentum, Lexikon für Theologie und Kirche, and Wörterbuch zum Neuen Testament under the relevant headings paradise, Eden, the Fall, and R.R. Grimm, Paradisus coelestis, Paradisus terrestris (Munich 1967). On Dionysius the Carthusian cf. Wirth (op. cit.) p. 43ff. (also p. 69 on Luther) and: Dionysius der Kartäuser, Opera Omnia vol. 22 (Montreuil 1930) p. 150ff. and p. 185ff. On the panels in the Doge's palace in Venice cf. Tolnay (see section A.) p. 110ff.; Marijnissen (see section A.) p. 300ff. with refe-

rences to Ruusbroec's texts. Documentation of the Grimani collection in Th. Frimmel (ed.), Der Anonimo Morelliano (Marcanton Michiels Notizia d'opere del disegno) (Vienna 1888) p. 102f. (the entries are from the year 1521). On D. Bouts' triptych and his iconography cf. A. Chatelet, Sur un jugement de D.B., in: Nederlands Kunsthistorisch Jaarboek 16, 1965, p. 17ff. and Belting Kruse (see section A.) p. 213f. On Sebastian Brant's Ship of Fools cf. the data in section E. On Erasmus' Praise of Folie cf. W. Schmidt Dengler (ed.), Ausgewählte Schriften des Erasmus vol. 2: Moria's Enkomion (Darmstadt 1975) and the editions by A. Hartmann (1960) and in the Diogenes series (Zurich 1987). Cf. also J. Huizinga, Erasmus (Haarlem 1924); M. Foucault, Histoire de la Folie (Paris 1961); B. Könneker, Wesen und Wandlung der Narrenidee im Zeitalter des Humanismus (Wiesbaden 1966). On the marginal illustrations by Holbein 1515–16 cf. U. Schultz (ed.), Erasmus von Rotterdam, Lob der Torheit mit den Handzeichnungen H. Holbeins d.J. (Bremen 1966).

RIVAL DREAMS OF PARADISE

On the cartography cf. J.B. Harley and D. Woodward (ed.), The History of Cartography vol. I (Chicago 1987) and on the conflict with local maps from other cultures D. Leibsohn, Colony and Cartography, in: C. Farago (ed.), Reframing the Renaissance. Visual culture in Europe and Latin America (Yale Univ. Press 1995) p. 265ff. On the names for paradise cf. the references in section G. On Dürer's drawings of the lion and the walrus cf. F. Winkler, Die Zeichnungen A. Dürers vol. IV. (Berlin 1939) p. 20ff. with no. 779, 781, 823 and 824 (also p. 42 no. 822 on the drawing of the menagerie); Cf. I.M. Massing, The quest for the exotic: A. Dürer in the Netherlands, in: I.A. Levenson (ed.), c. 1492. Art in the age of exploration (Washington 1991) p. 514ff. On Dürer's remarks on the garden cf. Rupprich (see section F.). On the garden and game enclosure at the ducal palace on the Coudenberg cf. A. Henne A. Wauters, Histoire de la Ville de Bruxelles vol. 3 (Brussels 1845) p. 329ff.; above all P. Saintenoy, Les Arts et les Artistes à la Cour de Bruxelles vol. 1 (Brussels 1931) p. 65ff. with most of the known sources (cf. also vol. 2 p. 144ff.); P. Lombaerde, P. Sardi und die Wasserkünste des Coudenberg Gartens, in: Gartenkunst 3.2, 1991, p. 159ff. (on the later history and on the waterworks); K. de Jonge, Der herzogl. und der kaiserl. Palast zu Brüssel, in: Jahrb. des Zentralinstituts f. Kunstgesch. München vol. 5–6, 1990, p. 253ff. and again, Het paleis op de Coudenberg te Brüssel, in: Belgisch Tidskrift voor Oudheidskunde 60, 1991, p. 5ff. On the history of the Renaissance garden in the Netherlands cf. exhibition catalogue Tuinen van Eden, ed. R. de Herdt (Gent 2000) passim and p. 34f. plus 121f. on Brussels. On keeping animals, see C. Lazzaro, Animals as cultural signs, in: Farago, 1995 (op. cit.) p. 197ff. On the collections of objects from the New World cf. P. Vandenbroek, America: Bride of the Sun (Catalogue Antwerp 1991) p. 99ff.; A. Shelton, Cabinets of transgression and the incorporation of the New World, in: I. Elsner R. Cardinal (ed.), The cultures of collecting (London 1994) p. 177ff. On Dürer's involvement cf. D. Eichberger, Naturalia and Artefacta: Dürer's nature drawings and early collecting, in: D. Eichberger C. Ziska (ed.), Dürer and his culture (Cambridge 1998) p. 13ff. Dürer's account in Rupprich (see section F) p. 155. On the assimila-

tion of Aztec images cf. above all S. Gruzinski, La guerre des images (Paris 1990) p. 23ff. (Columbus), 30ff. (Petrus Martyr) and 44ff. (changing views since H. Cortès). On modern primitivism and its myths of origins cf. H. Belting, Das unsichtbare Meisterwerk (Munich 1998) p. 37ff. and 388ff.

THE ISLE OF NOWHERE

The definitive edition: E. Surz, J.H. Hexter, Utopia (Complete Works of Th. More vol. 4, Yale Univ. Press 1965). See also G.M. Logan, R.M. Adams (ed.), Th. More: Utopia (Cambridge 1988) with the letters and deciations in the early editions cf. 112ff. (on these cf. P.R. Allen, Utopia and European Humanism: the function of the prefatory letters and verses, in: Studies in the Renaissance 10, 1963, p. 91 ff.). On the author cf. the extensive biography by P. Berglar, Die Stunde des Thomas Morus (Cologne 1978, 19994) with its chapter on Utopia (p. 211ff.). On Utopia cf. Ginzburg, No island is an island. Four glances at English literature in a world perspective (New York, Columbia Univ. Press 2000) p. 1ff. (The old world and the new seen from nowhere). On More's accompanying letter to Gillis cf. Logan, Adams (op. cit.) p. 3ff. On Lucian's role in More's and Erasmus' literary activities cf. the comprehensive work by C. Robinson, Lucian and his influence in Europe (London 1979) p. 129ff. (The imaginary voyage) and 165ff. (Erasmus) plus Ginzburg (op. cit.) Die 'wahren Geschichten' with a German translation by K. Mras (ed.), Die Hauptwerke des Lukian griechisch und deutsch (Munich 1954) p. 329ff. (esp. the relevant passage in the introduction) and 402ff. On Erasmus' characterisation of More cf. the dedication in Praise of Folie (see section G) and the letters 191 and 193 in the edition by Allen (see section K). On the significance of ecphrasis and the analogy with painting cf. Ginzburg (op. cit.) p. 5ff. and 13ff. On Busleiden cf. H. de Vocht (ed.), J. de Busleyden. His life and writings (Turnhout 1950). On Budé's letter cf. Logan, Adams (op. cit.) p. 115ff. On the Basel edition cf. section K.

FICTION AND HUMANIST PORTRAITURE: AN EXCURSUS

On the Basel edition of Utopia of 1518 with the woodcuts by A. Holbein cf. W. Hes, Ambrosius Holbein (Strasbourg 1911) p. 70ff.; Catalogue: Die Malerfamilie Holbein in Basel (Basel 1960) no. 121 and the fig. on p. 160, plus Morison, N. Barker, The likeness of Thomas More (Oxford 1963) p. 5 and 68. On the Garden as Paradise cf. references in section H. On More's letter to Erasmus of 15.12.1516 cf. P.S. Allen, Opus Epistolarum Desiderii Erasmi Rotteradami vol. 2 (Oxford 1910) no. 502. On Praise of Folie see references section G. On the introduction to Utopia and the letter of dedication to Gillis cf. references in section I. To the open letter to M. van Dorp and on the Education of a Christian Prince (Institutio Principis Christiani) cf. Berglar (see section I) p. 229ff. and A.J. Gail, Erasmus von Rotterdam (Rowohlts Monographien 1974) p. 59ff. and 79ff. Among the selected writings of Erasmus edited by G. Christian, see Institutio Principis Christiani (Ausgew. Schriften vol. 5, Darmstadt 1968). On the portaits of Quentin Massys cf. L. Campbell among others, in: The Art Bulletin 908, 1978, p. 716ff. (there too the discussion of the letters) and L. Silver, The paintings of Quentin Massys (Oxford 1984) p. 105ff. The important letters from friends referring to the paintings, in the Latin editions of the letters by P.S. Allen (op. cit.) nos. 584, 597, 601, 616, 654, 669 and 681 (dispatch of the portraits) and 684 (long letter by More including the verses he composed for the paintings), and 687 and 688 (the English translation in the editions by R.A. Mynors and D.F. Thomson, The correspondence of E., Toronto 1975, were not available to me). On the significance of the humanist portraits, cf. H. Belting, Wappen und Porträt, in: H. Belting, Bild-Anthropologie (Munich 2001) p. 136ff. On the role of Holbein and his portraits of Thomas More cf. Morison Barker (op. cit.) p. 7ff. (including reference to Baldinucci) and the catalogue: Holbein and the Court of Henry VIII (The Queen's Gallery, Buckingham Palace 1978) p. 25ff. (More) and p. 31 (Erasmus).